South Devon's
SHIPWRECK
Trail

South Devon's SHIPWRECK Trail

Jessica Berry

Illustrated by
Jovan Djordjevic

AMBERLEY

About the Authors

Jessica Berry used to be a journalist for the UK Sunday broadsheets with stints in the Middle East before settling in the UK as an investigative journalist. She gave that up after about 15 years to pursue an entirely different career. She is now a maritime archaeologist who runs her own charitable company. She spends a lot of her time underwater and is otherwise based in London.

Jovan Djordjevic is relentless in his pursuit of the visual arts. Having worked for decades as an inter nation freelance illustrator he has the ability, skills and talent to research and deliver stunning conceptual visual solutions; for all sorts of briefs. His past illustrations have appeared in numerous editorial publications (National Press and Magazines), books, design and advertising commissions. He currently creates 'Wall Art' for a variety of clients as well as being involved with – print making, faux postage design and manufacture, teaching, painting and exhibitions. Jovan lives and works in Wivenhoe, Essex. www.jovandjordevic.com

First published 2013

Amberley Publishing
The Hill, Stroud
Gloucestershire, GL5 4EP

www.amberley-books.com

British Library Cataloguing in Publication Data.
A catalogue record for this book is available from the British Library.

ISBN 978 1 4456 0674 3

Typesetting and Origination by Amberley Publishing.
Printed in Great Britain.

Contents

	Foreword	9
	Preface	11
	Introduction	13
	Acknowledgements	21
Chapter 1	*Coronation*	23
Chapter 2	Eddystone	27
Chapter 3	Blackburn Iris	32
Chapter 4	*Maria* Submarine	37
Chapter 5	HMS *Conqueror*	43
Chapter 6	HMS *Amethyst*	49
Chapter 7	Church Rocks	53
Chapter 8	Mewstone Site	59
Chapter 9	*San Pedro el Mayor*	67
Chapter 10	HMS *Ramillies*	71
Chapter 11	SS *Persier*	77
Chapter 12	HMS *Stockforce*	81
Chapter 13	*Herzogin Cecilie*	87
Chapter 14	*William and Emma*	91
Chapter 15	HMS *Crocodile*	95
Chapter 16	Moor Sands Sites	101
Chapter 17	*De Boot*	105
Chapter 18	HMS *Penylan*	111
Chapter 19	HMS *Venerable*, HMS *Cerbere* and T-189	115
Chapter 20	*Tyger*	121
	Glossary	125
	Bibliography	130

To my parents

They that go down to the sea in ships, and occupy their business in great waters. These men see the works of the Lord; and his wonders in the deep.

Psalm 107

Foreword

The sea even now plays a major role in the life of the United Kingdom. The Royal Navy is one of the world's blue water navies, and Britain's maritime industries contribute over £45 billion to the UK economy annually – over 90 per cent of goods and 50 per cent of the nation's energy arrive by sea.

Yet the UK's population today understands very little of the sea. The decline of Britain's maritime industries (transport, fishing and shipbuilding) since the Second World War means that few civilians, even in traditional maritime communities such as Liverpool and Southampton, earn their living from the sea. Even the Royal Navy, for 250 years the largest in the world, is a shadow of its former self, left with only thirty-two major warships – just over 6 per cent of its size in 1945. With international air travel now so cheap, almost anyone can be on the other side of the world in less than twenty-four hours. For the British, the sea is no longer a place to earn a living, but is rather a holiday destination, a place in which to sail, surf or swim.

With the decline of maritime industries has come the removal from the landscape of the evidence of Britain's former glories. Much of the maritime infrastructure, such as ports and harbours, has either been taken over by other industries or gentrified for housing and leisure use. But there is one place that has so far remained safe from developers, and that is the vast underwater world which holds evidence of seafaring over millennia.

Situated on the maritime approaches to North West Europe, the British Isles form a vast navigational hazard for ships leaving or entering European waters. As a result, shipping movements around the islands have been considerable throughout time and so has shipping loss. Indeed, the British Isles hold the little known record for having more shipwrecks per mile of coastline than any other nation.

The average for these losses increases around prominent areas of maritime traffic, such as the Dover Straits and perilous regions like the Scilly Isles. The South Devon coastline forms one of these points. Situated to the north of the English Channel, the world's busiest seaway, and with a major naval port at Plymouth and other historic coastal and deep water ports at Salcombe, Dartmouth and Exeter, this coast has a long history of heavy maritime traffic. If you add to this the major navigation hazards of the headlands of Bolt Head and Prawle Point, jutting out into the English Channel to catch those unwary ships to the north of their intended path along the English Channel, the reason for shipping disasters is obvious.

The popular perception is that once wrecked, ships are lost to all time, broken up by the sea and dispersed by wind and tides. However, the development of maritime archaeology since the 1960s has shown that this is not always the case, and while

many ships are destroyed in this way, many also survive to one degree or another. The case of South Devon is typical. Along a shore, from which men have left by sea to fight the Crusades, the Spanish Armada, the Dutch, the French (on numerous occasions) and two World Wars, lie wrecks that relate to all of these periods and even predate them. Outside Salcombe, for example, lays the wreck of a ship from the middle Bronze Age, which is not only among the oldest in the world but also contains some of the most ancient links between the civilisations of the Mediterranean and northern Europe.

Some of the most recent of these wrecks provide memorials to quite modern history – the sailing ships of the late nineteenth century, the Battle of Jutland, and perhaps, most numerous, the battle against the U-boats in the two World Wars. Others provide even more tantalising information: as a result of archaeological work along Devon's southern coastline, we have been able to learn about the prehistoric trade in south-western tin trade and exchange in the Bronze Age, sixteenth-century shipbuilding, seventeenth-century trade with North Africa, and life at sea in Royal Navy in the eighteenth and nineteenth centuries.

When you walk along the 100 or so miles of Devon coast and look out to sea, it is over the remains of these ships that you are gazing. This book is the perfect companion.

Dave Parham
Bournemouth University

Preface

Although some of these wrecks have never been found, many others have been systematically studied by underwater archaeologists – amateur and professional alike – over many years, and it is to them that we owe a debt of gratitude. Historical documents can tell us a great deal, but they can also be fragmentary. Archaeology is the nuts and bolts, the study of the physical remains of how man left his mark on the world, which in some cases can also contradict the written record. A bit like a crime scene, the divers, armed often with no more than tape measures and cameras, methodically sift through shipwreck remains, paying close attention to what might at first appear inconsequential, such as the gnawed remains of an animal bone. These remains could have the power to inform on how wealthy those on the vessel were, the distance of the intended voyage, or even what type of vessel it was, depending where on the site the artefacts were found. (A galley in the bow upper works, for instance, would normally suggest a merchant rather than warship.)

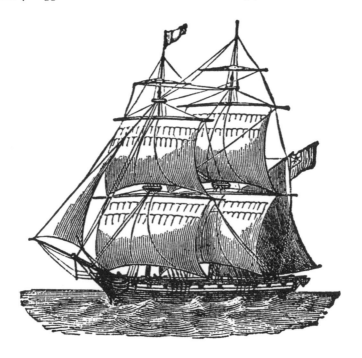

Excavations of a mid-eighteenth-century rubbish tip on Newport, Rhode Island, revealed the extent of how unsuccessful the Navigation Acts had been in preventing

smuggling of alcohol, mainly Dutch gin. Whereas the historical archives had been piecemeal, the artefacts were testament to how goods were smuggled.

Shipwrecks have often been described as time capsules, where after the single, catastrophic event, everything remains as it was, caught in that moment in time. This type of situation is quite rare because it relies on the wreck remaining not only in the position it sank, but also uncontaminated by later wrecks or salvage or divers themselves. In one wreck in Victoria, Australia, archaeologists found golf balls. They were not part of the cargo, but rather had been deposited by divers who had used them to wedge open iron plating in order to reach more inaccessible areas.

Underwater archaeology is multidisciplinary. It regularly requires experts in various fields such as geophysics, geology, dendrochronology and specialists in historical research, ceramics and leather to name a few. It is a relatively new discipline that began in the 1960s – then led principally by volunteers, divers with an interest in wrecks, many of them former naval personnel. It was seen as an adventurous sport for the fearless few passionate about wrecks and even treasure.

Many of the sites mentioned in this book were found and researched by self-funded volunteers. Later, in the following decade, it was possible to take postgraduate courses in the subject. Gradually, the law began to encroach on some of the divers' underwater activities. Dynamite to 'shiver' or loosen the timbers and other wreck artefacts like cannons that had become concreted into the seabed, became unacceptable. In 1973, it became illegal in the UK to remove artefacts from any wreck site designated under the Protection of Wrecks Act.

Today, the number of volunteers and professionals working in the discipline is waning. Although there are a variety of graduate and undergraduate courses available, there are few places where it is possible to gain the necessary experience, and there are even fewer jobs. The pioneers of the sixties, seventies and eighties, many of whom had naval experience from the Second World War, are growing old and hanging up their diving suits, and because the pay of the professional underwater archaeologist is small and the career is specialist, few are willing to take their place. Underwater archaeology is now practised in Britain by a limited number of volunteers and professionals with very limited government funding. Funding for research and fieldwork is now almost wholly reliant on sponsors and donations, and the ability of volunteers to finance themselves.

Introduction

At sea level the human eye can see clearly about 3 miles before the curvature of the Earth causes ships in the distance to disappear below the horizon. By climbing the crow's nest, seamen could almost double that distance.

This book is written for coastal walkers who like to be accompanied by a good story. If the wrecks in this book were on the surface they could be seen from land. That is the principal behind my choice of sites that range from the Bronze Age to the Second World War.

The sea has been Britain's lifeblood since prehistory, bringing trade from the Mediterranean during the Bronze Age to the establishment of domination of the world's trade routes in the eighteenth and nineteenth centuries, and its gradual decline since then. The inhabitants of Britain have been seafarers since possibly the end of the last

Ice Age, 8,300 years ago, although the earliest physical evidence of shipwrecks dates to 1,300 BC. So although popular maritime history of Devon often begins much later, Britain's earliest seafaring started when the ice caps that covered much of Britain began to melt, forming what is now known as the Channel River, a prehistoric freshwater forerunner of the modern day English Channel formed by the draining into the North Atlantic of the major European rivers such as the Rhine, Thames and the Seine. Then, around 1,500 years on the melting Eurasian ice sheet caused the sea levels to rise to the point where Britain first became an island. Until then, Britain's closest shores were around 200 miles to the south-west of today's Land's End in Cornwall.

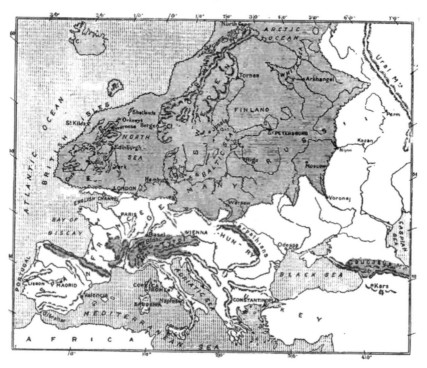

No properly dated boat remains have ever been found from these times, although paddles have, suggesting that perhaps voyages were made in skin boats, similar to those of the Inuit, who are capable of making extended sea voyages. It would be very likely, given the landscape in which these people lived, that they would have mastered the art of navigating rivers and other waterways. With such boats, Britain's new found status as an island would have not created isolation but rather the opposite.

Some elements of these lost land surfaces survive as redeposited stone tools within the gravels that form the bed of the modern-day English Channel, and as deposits of peat often found in river estuaries. The presence of tree remains in these peat beds give them their common name of submerged forests.

Three such forests exist in this part of the coast: in the entrance to the Erme Estuary where the remains of trees have been dated to 8,300 years ago, around the time of Britain's final split from the continent; and another at Inner Hope. At Thurlestone

Sands, a third forest was first discovered in 1866 and then again in 1923, when a number of tree trunks and stumps were found, a Mesolithic tranchet stone axe and a pebble mace head. The 1923 discovery included a dugout canoe, found buried within the forest. It was described as half of a trunk, 52 cm across, flat on the top and shaped underneath, with several parallel grooves which appeared to have been made with tools. If correctly identified, this would be Devon's oldest shipwreck. Sadly, however, the object doesn't survive to be re-examined and correctly dated with modern techniques.

Today, the UK boasts more wrecks per mile of coastline that any other nation on earth, due in large part to its position on the maritime approaches to Northern Europe. These are testament to hundreds of years of trade in cargo, people and ideas. At the time of their construction, they represented society's most developed or technologically advanced equipment, comparable to today's spacecraft, launching into the unknown. They, and the artefacts found in them (cannons, gold, tin, bronze, and simple articles of everyday life), have illuminated our understanding of our past and go some way in explaining man's extraordinary endeavours.

These fragile monuments range across all periods from some of the oldest in the world, dating from the Bronze Age to early twentieth-century submarines. Those that have been investigated by divers and archaeologists have made great contributions to our understanding of the past. We have learnt about long-distance connections with the Mediterranean in the Bronze Age, Tudor life and abilities, naval warfare during the English Civil War and the development of globalisation.

Between 1500 and 1800, the political and economic balance of the world changed and so too the course of history. The world in the 1400s was confined. The known trade routes out of Europe, established by Marco Polo, were mostly across vast, inhospitable land mass. Pepper in the fifteenth century was worth a small fortune. It would have been exchanged at least a dozen times before reaching its final destination.

As Syria and Egypt forbade Christian traders travel through their lands and seas, expensive Muslim intermediaries were the norm, as was a European trade deficit. The First Crusade, the aim of which had largely been to break through the Islamic blockade preventing cheap trade with the Indies, had failed. What was required was a special ship capable not only of sailing as far to windward as possible, but also of carrying sufficient men and supplies to travel into the unknown. The Age of Exploration, led by the voyages of Christopher Columbus, Bartholomew Dias and Vasco da Gama opened up new routes and possibilities. Devon, too, provided its own explorers. In the 1530s, William Hawkins, the father of Sir John Hawkins who later became Treasurer of the Royal Navy, had travelled to Brazil and had reached Guinea off West Africa. It was a Devonian, John Davis, who discovered the Davis Strait in 1587, and again a Devonian, Humphrey Gilbert, who founded Newfoundland, Britain's first North American colony, in 1583. By the 1900s, it was said that Tristram Coffin, also from Devon, who had emigrated to Massachusetts in 1642, had over 5,000 descendants living in North America. The list goes on.

Political changes had a massive impact on maritime trade. By the 1600s, the Age of Discovery slowly began to make way for the Age of Sail, and the height of empire building for the growing European states, among them Dutch, British, French, Spanish and Russian. By the second half of the eighteenth-century, crossing the globe was far less hazardous, thanks to technological innovations, both in shipbuilding and in navigation tools such as the chronometer, which measured longitude. As a direct result, discoveries, empire building and the establishment of lucrative trade routes made London and the ports of Devon the world's most important trading centres for centuries – and Britain the world's most powerful industrial nation.

Devon owes its fortunes largely to its geographical position. Aside from Cornwall, the county has more coastline than any other. It is one of only three counties, the others being Cornwall and Kent, to have a north and a south coast. The peninsula of South West England juts out around 130 miles into the Atlantic, and apart from the Lizard in Cornwall, the section of South Devon from Bolt Head down to Start Point is the southernmost point in Britain.

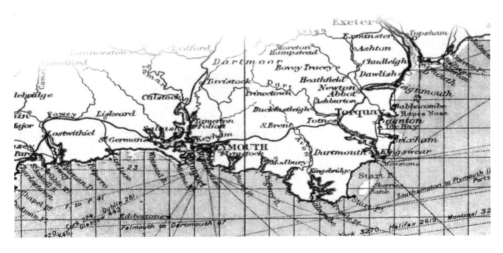

The southern coast of Devon, in particular, is known for its wide estuaries, such as the Dart and the Erme, and its natural harbours. All these factors have combined with Devon's geographical position in relation to its traditional enemies, France and Spain, to ensure that the county has had one of the richest maritime histories in the country, a status that I have reflected in this volume of shipwreck stories.

Some of the oldest shipwrecks in northern Europe lie along the South Devon coast, in part because, as the second southernmost point, the South Hams capes, the land effectively sticks out, and as a result traps unsuspecting ships, their captains reduced to guesswork by thick fog or swept onto the rocks by heavy gales. Historically, as now, the English Channel was one of the busiest shipping channels in the world, and these capes have formed a hazard to navigation since prehistory. They are a classic ship trap.

The earliest known shipwreck site in South Devon dates to the Bronze Age. Divers searching a section of coastline just to the west of the Salcombe estuary, an area now known as the Moor Sands site, discovered the earliest physical evidence of the prehistoric south-west trade in tin. Fantastic riches have emerged from the site, just off Prawle Point, dating back to 1300 BC. The finds, which have included tin and bronze ingots as well as gold jewellery and weapons, demonstrate a complex network of trade routes reaching as far south as the Mediterranean.

The South West's maritime history goes relatively quiet until Henry II's marriage to Eleanor of Aquitaine in 1152, which granted England control of south-western France. The union coincided with a period of development in tin mining in Devon and Cornish moors, which sparked the rapid growth of ports of Plymouth, Fowey and Dartmouth. These prospered quickly from the export of cloth and tin, and the importation of French wine through the fourteenth and fifteenth centuries. Plymouth's development into the West's official naval town began, however, as early as 1330, when forty large ships were assembled to restore order in the Duchy of Aquitaine. Just twenty-six years later, the port dispatched 300 ships, under the command of the Black Prince, to attack France. They returned the following year flushed with victory from the Battle of Poitiers with King John amongst their prisoners.

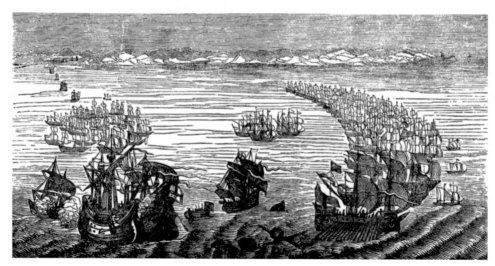

In the fifteenth century, there was a brief lull in trade. Bordeaux was lost and the growth of piracy, most of which was home-grown, reduced trade for legitimate merchants. In 1403, during the Hundred Years War, Breton forces sacked several important Devon ports, including Salcombe and Plymouth. They tried for Dartmouth the following year but were seen off.

The following century, Spain emerged as Britain's most important enemy. When the Armada arrived in 1588, as legend has it, Sir Francis Drake was playing bowls, and calmly announced that he would finish the game before defeating his enemy. Some reports state that as a result, his fleet of fifty-six ships was trapped by a flooding tide in the Sound for six hours before it could move out on the ebb to fight the enemy. On 21 July, the Battle of Plymouth was fought, watched by everyone in the town.

By the seventeenth century, Devon ports were wealthy and powerful, competing successfully with London for trade from North America. The Newfoundland trade

was so profitable that Dartmouth got a new quay and hundreds of new houses. Plymouth became an official navy base for the West in 1690, after the 1688 invasion by William III at Torbay brought home to the Admiralty that the Thames Estuary was not always the most practical centre.

From the eighteenth century, Salcombe built ships, including fruit schooners – fast ships built to transport fruit from Spain and the Azores. Right up to 1815, endless wars, against the Spanish and the French in particular, ensured the continued growth of

Plymouth as a naval base and, when the American War began in 1775, a huge growth in privateers – government-sponsored private ships used to attack enemy ships. When the war with France broke out in 1795, Parliament demanded that each county produce a certain number of men for the ships, like a tax. In two years Devon had to give up 902 men, nearly 3 times the amount required from either Cornwall or Dorset which only produced 326 'volunteers'. Meanwhile, Devon's smuggling tradition had become well entrenched. With the Admiralty revenue cruisers' attention focused on potential French invasions, and indeed open to bribery, smugglers grew rich. The Mewstone rock off Wembury, touched on in this volume, was once a magnet for looters.

By the end of the Napoleonic Wars, smuggling became more challenging as the revenue men changed their priorities. Overseas trade from Devon had fallen away and fishing took over as the biggest revenue earner. By the middle of the nineteenth century, Devon was becoming increasingly attractive to tourists, and wealthy families began to move there in droves, attracted by the soothing scenery and the healthy, smokeless climate. The once busy harbour of Salcombe is now a purely holiday destination, the town is deserted out of season.

During the Second World War, however, due to its proximity to France, Salcombe proved extremely useful. It was a base for RAF air sea rescue launches, and later a staging point for US forces prior to the Normandy Landings in 1944. Over 100 vessels from Force 'U', headed for Utah Beach, sailed from here on D-Day, 4 June 1944. The

remains of a landing stage, which was also used to repair damaged landing craft, is still visible at Mill Bay at Normandy Way. Opposite on Bolt Head, a radar station was installed alongside RAF Bolt Head.

Within the estuary itself, in fact a drowned valley, or ria, caused by rising sea levels, there are, among the yachts and tourist cafes, constant reminders of Salcombe's prominence in Britain's maritime past, right up to the Second World War. The banks and creeks of the estuary contain a wide range of sites linking the agricultural and industrial revolutions to seafaring, and Salcombe to other cities within and beyond the UK.

The stories of the shipwrecks and sites in this book provide brief glimpses into the main eras of South Devon's maritime past from the Bronze Age to the Second World War. It has sometimes been suggested that if the sea along this stretch of coast was drained, we could walk from one end of South Devon to the other, from wreck to wreck, much like hopping from bonnet to bonnet in a traffic jam.

Acknowledgements

The author would like to thank the staff at the British Library, Greenwich Maritime Museum, Fleet Air Arm Museum and the National Archives at Kew for their help and wisdom. She would also like to thank her family and the following people in no particular order for being so supportive: Peter McBride, Nigel Mortimer, Pete Holt, Mehreen Saigol, Rosanna Kelly, Dave Parham, Anthony Gardner, Neville Oldham, Dave Illingworth, Mick Palmer, Jim Tyson, Mick Kightley, Ron Howell, Andy Elliott, Dave Dunkley, Mike Kingston, Mike Williams, Julie Williams, Andy Wagstaff, Steve Clarkson, Mike Turner and the South West Maritime Archaeology Group.

Coronation

The *Coronation* was a second-rate, 90-gun ship with a crew of 660 officers and seamen. Built in 1685 as part of Samuel Pepys' restoration of the Royal Navy, her life was as dramatic as her wrecking. She is best known for taking part in the Battle of Beachy Head in June 1690.

Louis XIV, taking advantage of William III's fight in Ireland against James II, had begun to amass a fleet large enough to invade England. Its success, he hoped, would encourage a Jacobite rebellion in support of James on English soil.

The *Coronation* was the flagship of Vice Admiral Sir Ralph Delaval. While the fleet itself was led by Admiral Arthur Torrington, the *Coronation*'s captain was Charles Skelton, a man of impeccable lineage: he was the fifth son of Sir John Skelton, Lt Governor of Plymouth, and brother of Sir Bevil Skelton, Groom of the Bedchamber to Charles II and Captain of the Guards.

As a young man, Skelton had served first as the 2nd-Lt on the 50-gun *Gloucester*, taking part in the attack on the Dutch Smyrna fleet in March 1672. His ship attacked and, after several bloody hours, boarded the 54-gun *Hollandia*, the flagship of the Dutch Rear-Admiral Van Nes. Skelton had performed well. The *Hollandia*, though so badly holed she later sank, did yield some fine silk and 'much plate'. Skelton's reward was promotion. The following year he got his first command as captain of the fifth-rate *Speedwell*. He was appointed captain of the *Coronation* just before the Battle of Beachy Head. This time, however, his enemies were different. The bloodless revolution of 1688, which brought William to the throne in England, meant that France had replaced the Dutch as England's closest enemy.

The eight-hour battle was one of France's greatest victories over the Dutch and English during the Nine Years War. The English, heavily outnumbered, lost eleven ships, whereas the French lost none. For Admiral Torrington, it ended in a court martial and disgrace.

The following year, the *Coronation* was part of a Dutch and British fleet under the command of Admiral Russell, patrolling the English Channel in search of the French fleet. The fleet, this time, was strong with fifty-seven British and seventeen Dutch ships. Russell was under orders to avenge their latest spectacular defeat. The *Coronation* was again commanded by Skelton, who had by now amassed considerable experience at sea.

The weather that summer of 1691 was memorable for particularly harsh gales. The fleet had spent significant time sheltering in bays along the coast, failing to engage a reluctant enemy. In August, logbooks of the *Royal Oak* noted 'squally weather blowing very fresh', which soon developed into 'very squally stormy weather'. The wind, blowing at first from the south and south west, had blown the ships swiftly home towards Plymouth. But then, at the last minute it changed to the south-east, blowing right across the entrance to Plymouth Sound.

The wind's attack on the *Coronation* was merciless. Skelton tried in vain to anchor off Penlee Point, just to the west of the Sound, to avoid hitting the rocks. In a desperate attempt to save his ship, he ordered the masts to be cut down. But he might have saved his breath – the gale complied before his men could obey his orders.

An eye witness, Edward Barlow, wrote in his journal: 'The *Coronation* coming into the Sound, her anchors being let drop, and veering out cable to bring her up, she took a salley and sank down in about 22 fathom, [40 metres] having on board above 500 men and not above 20 of them saved, and a ship on 90 guns, a very dreadful accident and a great loss, and the real cause was scarce never known.'

The rest of the fleet did not escape unharmed. A third rate, the *Harwich*, was a total wreck, and both the *Royal Oak* and the *Northumberland* were grounded, though they were later rescued.

One of the earliest accounts of the storm details the chaos that ensued as the fleet tried to gain safe harbour:

The ships were so confusedly scattered that the greatest part of them were not seen when the Admiral himself came to anchor in the Sound: but when it grew somewhat clearer, one of the second rates (which proved to be the *Coronation*) was discovered at an anchor off the Ram Head, without anything standing but the Ensign Staff, and foundering soon after, her commander, Captain Skelton, together with her Company, except a very inconsiderable number, were lost. Many of the biggest ships were not able to weather the easternmost point of land at the entrance into Plymouth Sound, were constrained to take sanctuary there, in that confusion which a lee shore, thick weather, and a very hard gale of wind must unavoidably occasion.

The dramatic scene and loss of life was not, it transpired, the immediate priority of the Plymouth Port Agent, Captain Henry Greenhill, in whose letter to the Admiralty, the

drama came second to a housekeeping issue. 'The Admiral,' he wrote 'hath directed me to supply such ships as have received damage with what is of absolute necessity for enabling them to go up the river, which we are now about, and shall use the best husbandry possible and be as sparing as we can, though I fear this unhappy disaster will draw from us a considerable quantity of stores.'

Skelton drowned with his ship. The subsequent court martial acquitted him and his officers of any 'neglect or failure of duty'. One who had a lucky escape was the 1st-Lt, William Passinger, who had been left ashore at Falmouth, to collect fresh water and provisions. The ship remained undisturbed until a chance sighting of a cannon in 1967. Ten years later, divers and researchers were grateful for Skelton's distinguished lineage: the chance finding of a pewter plate, bearing the Skelton family crest, enabled them to finally positively identify the wreck as the *Coronation*. The site is now protected under law so that only divers licensed by English Heritage are permitted. This is to try to prevent looting of artefacts from the site.

Eddystone

Portsmouth, Plymouth, Weymouth, and most of our Sea Port Towns look'd as if they had been Bombarded, and the Damage of them is not easily computed ... 'Tis endless to attempt any further Description of Losses, no place was free either by Land or by Sea, every thing that was capable felt the fury of the Storm; and 'tis hard to say, whether was greater the loss by Sea, or by Land; the Multitude of brave, stout Sailors is a melancholy subject, and if there by any difference give the sad Balance to the Account of the Damage by Sea.

Daniel Defoe, *The Storm* (1704)

Constructing a lighthouse in the seventeenth century required courage and persistence, as any request had to be submitted to Trinity House, a powerful body entrusted with the safety of mariners. It invariably refused the venture on the grounds that it required the monopoly on the project. A speculator would likely incur considerable expenses. In 1696, however, a patent was granted and Henry Winstanley set about constructing a lighthouse on the treacherous Eddystone Rocks 14 miles south of Rame Head off Plymouth.

The rocks are submerged at high spring tide making their passage very often a gamble. Winstanley became utterly devoted to his task. For two years he and his workmen laboured, protected at all times by a guard ship, except for one undefended week in June 1697. Profiting from the guards' absence, a French privateer swooped in, seized Winstanley and took him back to France. The Admiralty was furious and demanded his return: they were surprised to find their demands met immediately. Within days, the mechanic was back at work and Louis XIV was scolding the privateers for their foolishness. 'France is at war with England, not with humanity,' he declared.

By the following year, Winstanley had fixed a solid, 4-metre-high, 5-metre-wide foundation on the rocks. A polygonal-shaped lighthouse was placed on top. Yet by 1699, a year of strong winds, the lantern was frequently blown off. Winstanley worked tirelessly to strengthen the base, and by 1703 declared his creation (whose diameter was now increased to 6 metres) impregnable, scorning detractors who suggested otherwise.

On 26 November 1703, the skies over Plymouth had darkened and a westerly breeze had set in. The town sensed a storm coming and Winstanley an opportunity to prove his faith in his creation to his naysayers. That night he took a boat out to the lighthouse to sleep.

Daniel Defoe reported the dramatic events in his journal:

This tempest … blew with such violence, and shook the lighthouse so much, that, as they told me here, Mr Winstanley would fain have been on shore, and made signals

for help; but no boat dared go off to him; and to finish the tragedy … when the tempest was so redoubled that it became a terror to the whole nation, the first sight there seaward that the people of Plymouth were presented with in the morning after the storm was the bare Eddystone, the lighthouse being gone; in which Mr Winstanley and all that were with him perished, and were never seen or heard of since.

But that which was worse still was that, a few days later a merchant's ship called the *Winchelsea*, homeward bound from Virginia, not knowing the Eddystone lighthouse was down, for want of the light that should have been seen, run foul of the rock itself, and was lost with all her lading and most of her men.

It was not until 1706 that work began on a new lighthouse. The intervening period saw some of the most memorable shipwreck scenes that Plymouth had witnessed. Though the most dramatic of these could not have been caused by the lack of a light warning, Trinity House was no doubt reminded of the perils that seamen faced in Plymouth Sound.

Daniel Defoe was on the shore at Plymouth at the time of the storm in August 1704, when he saw a fleet of fourteen ships pull in to the Sound. Crew and passengers alike rejoiced, for none had seen land since they had left Barbados weeks before. Most of the inns of Plymouth were full that night, the crew having left the ships anchored next to Cattewater. The evening was calm with little breeze, but Defoe sensed something was amiss in the night air. He was right.

The night after, it blew a dreadful storm … About midnight the noise, indeed, was very dreadful, what with the rearing of the sea and of the wind, intermixed with the firing of guns for help from the ships, the cries of the seamen and people on shore, and (which was worse) the cries of those which were driven on shore by the tempest and dashed in pieces. In a word, all the fleet except three, or thereabouts, were dashed to pieces against the rocks and sunk in the sea, most of the men being drowned. Those three who were saved, received so much damage that their lading was almost all spoiled. One ship in the dark of the night, the men not knowing where they were, run into Cattewater, and run on shore there; by which she was, however, saved from shipwreck, and the lives of her crew were saved also.

Nothing was to be seen but wrecks, and a foaming, furious sea in that very place where they rode all in joy and triumph but the evening before.

The next lighthouse, designed by a London silk merchant, John Rudyard, was completed four years later in 1709. Labourers were at first reluctant, remembering Winstanley's abduction by the French a few years previously. With Louis XIV's direct assurances and the Admiralty's promise of protection, they were eventually persuaded return to work.

Rudyard's lighthouse withstood many storms and survived until December 1755 when it was burnt to the ground after a lantern caught fire. Three lighthouse keepers were finally rescued some five hours after the fire had broken out. One died after swallowing a lump of molten lead. It was an engineer, John Smeaton, who fought to build a new lighthouse of granite.

The first two had been built of wood on the premise that if a ship can survive storms at sea, then so too could a wooden pillar-like construction. Timber would provide the elasticity needed, so the thinking went. Smeaton's new granite lighthouse was completed in 1759, using the silhouette of an oak tree trunk as a model. This was placed on a vertical cylindrical base.

It weathered storms for over 100 years, with waves sometimes breaking over the top. By then, engineers had begun to notice the tower sway in strong winds. With the memories of its chequered past still sharp, the lighthouse was brought down and moved to Plymouth Hoe on a new base, where it still stands both as a tourist attraction, and a memorial to Smeaton. A new, fourth lighthouse, designed by James Douglas, replaced it and was first lit in 1881. Douglas was knighted for his feat, which stands 49 metres high, on top of which a helipad has been installed for maintenance. His tower and the remains of Smeaton's can be seen for 22 nautical miles.

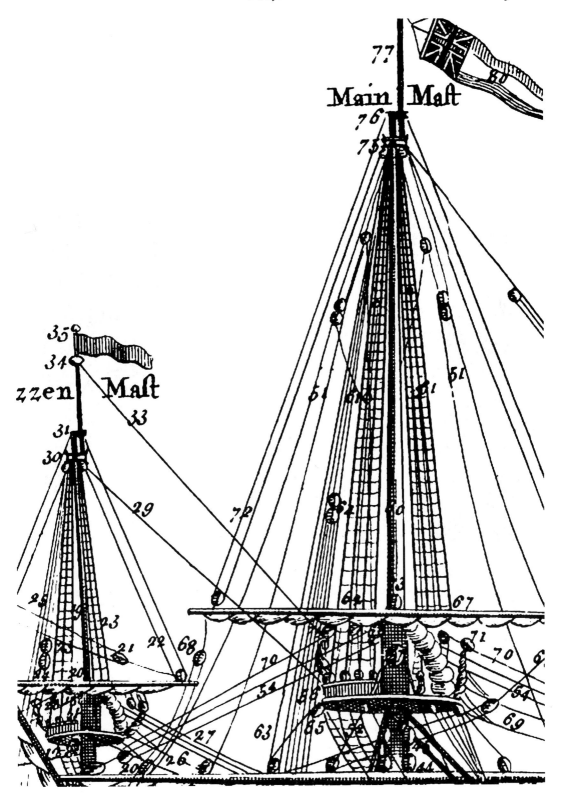

Blackburn Iris

The crash of the *Blackburn Iris* flying boat off Plymouth in 1931 was the worst disaster in the history of flying till that date. Nine men died in the spectacular crash, which was witnessed by 'Aircraftman Shaw', better known as Colonel T. E. Lawrence of Arabia. (After his heroic exploits in Arabia during the First World War, Lawrence had fled publicity by enrolling as an aircraftsman in the RAF, first under the assumed name of John Hume Ross, and then later, when he was found out, under the name of Thomas Edward Shaw.)

He had recently become heavily involved in the development of RAF marine craft, and was working at Plymouth at the time. It was as a direct result of the work of the RAF marine unit at Plymouth in the pre-Second World War years that the RAF was able to boast of a fleet of high-speed launches at the outbreak of the war.

The prototype Iris Mark III, N238, launched in 1929, was designed for long-distance flying. On one of its first test flights, it was flown on a 500-mile non-stop flight. The Iris IIIs was the largest craft in the RAF at the time, designed to carry five men and significant cargo, ammunition and a tone of fuel. Its last flight, however, was a training mission and there were twelve men aboard.

Witnesses described hearing a mighty crash but no flames. Harry Hole, in his boat near the scene at the time of the crash, had been watching the craft in gun practice some way out.

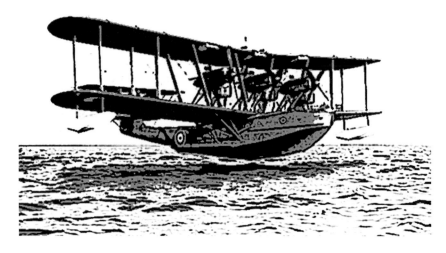

The visibility was good and the sea was flat. He said: 'we watched it flying towards Mount Batten when suddenly it struck the water, nose first, turned turtle, and then over on its side. It seemed the petrol tank had burst, as there was a lot of petrol running out, but there was no explosion and we saw no smoke or flame.'

The appearance of Aircraftman Shaw at the inquiry caused quite a stir. The celebrity's presence made front-page news in most of the newspapers, many of whom began their articles with physical descriptions of the star. He was described in one as a 'short, compact figure, in the neat, well-fitting uniform of the services, with his buttons highly polished'. Aircraftman 'Shaw,' it continued, 'punctiliously adding "sir" to all his replies, inculcated a touch of humour into the sombre proceedings, when he was asked if he did any flying and he replied, "No, but I used to, sir".'

He told the crowded room how he had been watching the plane's approach after emerging from the haze over Rame's Head and circling Plymouth Sound before ploughing nose first into the sea. Shaw rushed out to the scene in an RAF boat after witnessing the crash, not knowing how many had been on board.

'The tail came up and her main planes crashed into the water.' The flying boat briefly vanished completely before coming to rest upside down. Just four men were rescued from the scene. Flying Officer Wood died an hour later from his injuries. Only one man, Corporal Barry, the wireless operator, escaped unscathed.

Shaw echoed the feeling of most of his comrades when he told the inquiry that he had held a poor opinion of Wing-Commander Charles Tucker's skills in a flying boat. Tucker, who was a forty-five-year-old experienced land pilot, had little knowledge of the seaplanes or seamanship, and had been under instruction at the time the N238 crashed. It transpired that few relished the idea of flying with him. When Shaw was asked if he would have, he replied 'had I been ordered as a matter of duty to have flown with him, I would have done so, but not for choice'.

'Have you heard any expressions as to going up with Wing-Commander Tucker?'

'Yes, I have.'

'What was the nature of that?'

'A recommendation against doing so.'

Squadron Leader Jones added that though a promising pupil, he would not have put Tucker in charge of 'a boat for a long time'.

Flight Lieutenant Ely added further drama to the proceedings. Too badly wounded to be in court, the court adjourned to his bedside in the sitting room at the Royal Naval Hospital, where he lay propped up by cushions, mostly with his eyes closed, with a roaring fire in the fireplace. The coroner stood at the foot of his bed and the jury grouped around him. The press, meanwhile, used billiard tables as desks. Ely told how, despite having flown with Tucker before and landing safely, this time he had had a premonition of danger. Despite being junior in rank to Tucker, who was also a squadron leader, Ely was his instructor. This placed him in a difficult position. 'The point is that if he had been an officer under instruction, whatever his rank, I should have felt justified in taking control away from him.'

During that last flight, Ely was in the first pilot's seat on the left, and Tucker in the second pilot's seat beside him. After landing once during the practice firing session, Tucker was given control of the plane. But while Tucker made his approach to land, Ely made two separate attempts to regain control of the craft. He placed his hands lightly on the wheel to indicate he wanted to take over, but Tucker merely brushed his hands away crossly. 'It seemed to me that Wing-Commander Tucker had completely lost sight of the water, because instead of flattening out, he pushed the stick forward to approach nearer to the water before flattening out.

'I at once grabbed the wheel,' continued Ely, 'and pulled the control back, but though I saw the nose of the machine start to come down, it was too late and the boat struck the sea and crashed.'

'If you yourself had had full control, do you think, under all the circumstances, you would have landed safely?'

'Yes, I do.'

The jury reached its decision on apportion of blame within eight minutes, returning a verdict of error of judgement on the part of Tucker due to his inexperience.

Outside the courtroom, the incident plagued the old rivalries between the RAF and its Fleet Air Arm. Tucker's inexperience was blamed partly on the RAF. The Wing-Commander, it was argued, should have had a preliminary training in seamanship to understand how to control an amphibious aircraft. 'The Royal Navy,' an editorial in the *Morning Post* stated incorrectly, 'has its own air-arm; but the flying boats are under the Royal Air Force, which, or so it seems to us, is one of the anomalies of an anomalous system … we see the result of unsound reasoning in the extravagant claim that the Royal Air Force by itself can guard a frontier or subdue a hostile country.' In fact, by April 1918, the short-lived but highly successful Royal Navy Air Service had already merged with its poorer relation, the Royal Flying Corps, to form the Royal Air Force. The *Morning Post* was referring to the Fleet Air Arm formed in 1924 under RAF ownership. The newspaper was correct on one account though: rivalries were rife.

Maria Submarine

As a preface to a study on diving bells, Charles Babbage, the nineteenth-century inventor, once wrote 'the art of diving, unaided by any mechanical means, is known and cultivated by almost all uncivilised nations which dwell in the vicinity of extensive waters'. Naturally, he observed, that 'the very limited time during which man could remain underwater without a supply of air, would suggest the advantage of some method of enabling him to convey it down to him'.

This is precisely what John Day attempted to do some forty years earlier in 1774 in Plymouth, although, unfortunately, according to the censorious Babbage, he was 'an illiterate man in indigent circumstances'. His plan to sink a specially adapted sloop to a depth of 90 metres (295 feet) for twenty-four hours required a backer. He wrote to Charles Blake, whose name he found in the Sporting Calendar, to describe his ingenious plan. He had already tested it, he wrote, on the Norfolk Broads at Great Yarmouth. He had dived a Norwich 'market-boat' to 10 metres where he had remained for twenty-four hours.

Blake, whose imagination was suitably engaged, and also drawn perhaps by the potentially large returns on his investment (Day suggested taking just 10 per cent of every £1,000 Blake might gain from selling the invention), accepted the challenge. So the submariner set about preparing the *Maria*, a 50-ton sloop. Within it he built an airtight chamber, four metres long, two and a half metres in height and three metres in width. Seventy-five empty barrels were added for buoyancy and 30 tons of stone ballast would make the vessel sink. These would be released in order to rise to the surface at the end of the dive. At the top was a square hole, just large enough for one man to climb through. The vessel, standing on a false bottom looked, according to observers, like a butcher's block.

As Day became increasingly excited about his experiment, Blake was warned that the pressure of the water at a depth of 90 metres could be too great for the chamber and that it should, at all costs, be reinforced. But Day was irrepressible. So impressed was Blake that he bet the project would succeed, reducing the required depth, though, to 30 metres (100 feet) and the time spent below to twelve hours as opposed to twenty-four. Blake lost as the bet only stood for three months.

Despite the setback of the reduced depth, a new date was fixed for 28 June 1774. Blake arrived to find the *Maria* painted red for the occasion. On the deck there were three buoys of different colours, that were to be signals to the surface: white to denote 'all well', red 'indifferent' and black, that he was 'very ill'. Day appeared exceptionally cheerful and clambered into his contraption with a hammock, a watch, a small wax taper, a bottle of water and a couple of biscuits. At first, the *Maria* refused to sink and a further 20 tons of ballast were added. Just then, Day stripped off his jacket, declaring to puzzled onlookers that he should 'have a hot birth of it'.

Blake and his servant watched as the 'submarine' descended. Accounts differ, but at some point there appears to have been an explosion of air on the surface. By two o'clock the following day, twenty-four hours later, thousands of spectators had gathered. But nothing came, not even a black buoy. Blake asked the captain of the frigate *Orpheus* that lay nearby for help to locate Day and his investment. Lord Sandwich, who happened to be in Plymouth, was also brought in and encouraged the dockyard workers to help. But nothing could be done. *Maria* had sunk to 40 metres.

Day had built an airtight but not pressure tight chamber. He would have died almost immediately once he had reached the bottom when the vessel imploded. This would account for the sudden expulsion of air witnessed on the surface.

'Thus perished a man,' wrote Babbage, 'whose intrepidity resulted from his ignorance of the dangers he encountered; and who fell victim to his obstinate confidence in the success of the plan, concerning which his knowledge was totally insufficient to enable him to judge.'

Blake, however, who had spent considerable sums already, was not to be deterred from finding some return on his investment. He had two goals. The first was to recover John Day, 'whose death I presumed not to be real, but a mere cessation of the animal functions, and whose congealed mass of blood would remain a considerable time, in so cold a region, before a chance of putrefaction could take place.' After all, he noted, 'we have had instances of extraordinary recoveries'.

The barges with the Spanish Windlasses and the Shores fitted
in order to keep them asunder.

Surface of water

The Vessel on the bottom of the sea being secured to the Fore
and Aft Sweeps with also the Jewel Ropes or Messengers.

Contemporary line drawing and descriptions of the salvage operation for lifting the vessel.

His second aim was to recover the vessel itself, to understand the reason for the experiment's failure, and to 'discover such facts as might prove of future advantage to the world'. When he announced his plans, however, his backers slipped away. Lord Sandwich excused himself on the grounds that Day was clearly dead, and both Admiral Amherst and Sir Frederick Rogers, the Navy's commissioner at Plymouth, on learning of Lord Sandwich's response, politely but firmly declined to help.

Blake was rather surprised by the reaction of the King's men, yet undeterred. Locating the vessel was achieved fairly swiftly. Dragging a grapnel at decreasing depths they began to recover splinters of fresh wood, and then strips of red paint. The *Maria* had been found at a depth of 40 metres, around 270 metres off Drake's Island in a soft clay bottom. The process of recovering her, though not without incident – Blake fell in at one point but carried on 'without shifting his clothes, pursued my work without the least impediment to my mental faculties or health' – followed a fairly standard procedure. After managing to lash their ropes around the vessel at low tide with the use of two barges, they waited for the flood to raise it. *Maria* was brought within 90 metres of Drake Island, where, with Blake asleep from exhaustion, a rope snapped under the strain and the *Maria* was once again on the seabed, where it's believed she still remains. The rapidly rising costs and a summer of strong gales combined to defeat Blake's attempts. He retired knowing 'I must have succeeded at last'.

Day's attempt to build a submarine was by no means the first. Nathaniel Symons from Totnes in Devon tried to submerge his diving machine in the Dart in 1749. Little is known, however, of his contraption, though he apparently returned alive three quarters of an hour later. Cornelius Drebbel is widely held to be the inventor of the submarine. With James I as his patron, he held successful trials in the Thames of a boat powered by oarsmen underwater at a depth of five metres while breathing snorkel air.

HMS *Conqueror*

HMS *Conqueror* was a third-rate, 68-gun ship and carried a crew of 520 men. She was just the second ship to carry the name. Despite her short life (only two years) she is remembered for her success against the French in Lagos Bay in Portugal in August 1759. After years of military failures, marked in 1754 by the loss of Minorca, the victory at Lagos Bay became associated with the 1759 *Annus Mirabilis*, in the middle of the Seven Years War against the French-led enemy. The year 1759 was later identified as the year that Britain took over as the dominant world power from France.

The *Conqueror*, under the command of Captain Robert Harland, was part of Admiral Edward Boscawen's fleet. The mission was to prevent Louis XV's planned invasion of England and Scotland. The English fleet was moored at Gibraltar on 17 August when two frigates from the French fleet were spotted trying to sneak past the fleet through the Straits. Boscawen immediately gave the order to pursue, and his fleet of twenty-nine ships chased what transpired to be only seven French ships north up the coast of Portugal. By one o'clock the following afternoon, eight of Boscawen's fleet had surrounded the French.

The battle was bloody. Boscawen was forced to transfer his colours from his ship, the *Namur*, to the *Newark*, after it was badly damaged. The French fled. Four ships were later found sheltering in Lagos Bay. Admiral de la Clue, the French commander, was wounded when his flagship, the *Ocean*, ran aground under full sail losing all three masts. Her crew escaped inland. Meanwhile, the three remaining French ships sought protection under Portuguese neutrality, but the British forced their way into the bay and captured two ships, the *Temeraire* (the second HMS *Temeraire* fought under Admiral Horatio Nelson at Trafalgar in 1805) and the *Modeste*, and burnt the remaining *Redoubtable*. The French were terminally weakened. Only two French ships made it up to join the Atlantic fleet in Brest, resulting in the rout at the Battle of Quiberon Bay in November that year.

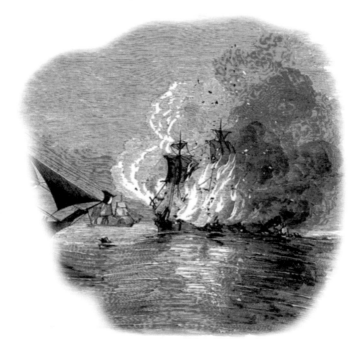

The *Conqueror* won the Battle Honour for the attack, and Boscawen himself became Privy Councillor and was promoted to General of the Marines. After the battle, the *Conqueror* became the flagship under Vice Admiral Thomas Broderick in its blockade of Cadiz against the French who had taken shelter there.

Her brief, yet victorious life was in sharp contrast to her comparably mundane end off Drake Island in Plymouth Sound on 26 October 1760. The captain, William Lloyd, was brought ashore, after which he ordered his ship to be taken up the Hamoaze, guided by a pilot Henry Harris. The wind was freshening from the south-west, making her manoeuvring difficult. As the wind picked up, she slipped 'the wrong way'. Immediately, the anchor was let go, but this didn't work and 'she drove, and continued so to do till she struck the rocks the SE part of the island when they cut away all her masts'.

The 1st-Lt Frederick Rogers ordered the firing of the ship's cannons to signal distress. Taking the master shipwright with him, they rushed to the dockyard to see what help they could get. 'But she was fast on the rocks,' explained Rogers, and nothing could be done.

Harris' breathless account illustrates the drama of the occasion. It appears he was keen to demonstrate that he was not to blame, and that the accident happened despite his experience.

Whilst the ship was unmooring, the wind shifted to SSE ... the topsails were loosed and sheets hauled home, the yards braced to the wind for casting the ship to the eastward; as soon as that was done the ship started her anchor from the ground, and casted to the westward ["the wrong way"], the anchor was immediately hove up, and the sails braced about and filled to stand into Cawsand Bay to slow the anchor, soon after which the Man at the Helm ran the ship up in the wind; I then ordered the mizzen to be hauled up, and the weather braces hauled in ... I then ordered the foretopmast staysails to be hoisted, in doing which the sheet broke, on which I ordered the jib to be hoisted, charging the Man at the Weather Helm (as I had done several times before) to be sure to keep a good weather helm, who answered me the helm was hard a weather, but before the jib was hoisted the ship flew in the wind again, and thinking her too near the shore to box her off again, I ordered the small bower [anchor] let go, and veered about half a cable's length, when I brought her up and she just tailed ashore.

I ordered the sails to be furled, and a messenger to be brought to heave the ship ahead again. As soon as this was ordered the Master came up on the quarter deck, and in the presence of the First Lieutenant ordered the head sails to be filled and the cable to be cut, which I forbade, saying to the Master by no means cut the cable … I told him that was owing to the cable being on the bows, which, if cut, the ship would soon be bodily ashore, to which he answered she was ashore already, and the only way to save her was to cut the cable.

The pilot stood his ground against the Master, declaring he could not consent to cutting the cable – being all 'that kept her from the shore'. The Master, however, 'immediately ordered the cable to be cut away'. As predicted, according to Harris, 'the ship fell off with her broadside on the rocks'. An hour later, the ship was flooded and the men were ordered off. The vessel was stripped over the next few days. All that remains near the site of the sinking are quantities of lead musket shot.

HMS *Amethyst*

HMS *Amethyst* was a 38-gun royal navy frigate. Her chaotic and inglorious end, battered on the rocks by Withy Hedge, Mount Batten in Plymouth, did not reflect her career.

The *Amethyst*, the second ship of that name, carried 260 crew and was a big ship for her day. (The first *Amethyst* was a French prize, the *Perle*, captured at the siege of Toulon in 1793.)

After her launch at Deptford in 1799, one of her first duties was to carry the Duke of York over to Helder in the Netherlands as part of an Anglo-Russian force to fight the Dutch. This ended in defeat and forced evacuation. A year later, however, the ship's fortunes were reversed. Under the same captain, James Cooke, the *Amethyst* was part of a fleet of eighteen vessels commanded by Sir Edward Pellew, whose orders were to assist the French royalists. The fleet anchored at Quiberon Bay on the north-west coast of France. Within two days, after dispatching a landing party, they had destroyed two forts, had burnt an 18-gun French sloop and taken 100 prisoners. Only one English seaman died in the fight.

Later that year, the *Amethyst* was part of a detachment of eleven ships under the command of Rear Admiral Sir John Warren, on orders to launch an attack on six Spanish ships of the line at Ferrol, North West Spain. But despite their success, Warren decided to abandon his advantage and retreat, concerned by the build-up of Spanish forces. A subsequent order to take Cadiz was also perhaps wisely abandoned when it was discovered that there was plague in the town.

The *Amethyst* went on to take several prizes, one of the most significant being the *Thetis*, in 1808. She was a 40-gun French frigate with 436 men ranged against the *Amethyst*'s 261. The battle in which both ships lost their mizzen masts raged for over three hours off Ile de Groix. The *Amethyst* prevented an attempt to board her, setting fire to the enemy before capturing her an hour and 20 minutes later. The *Thetis*'s loss was significant. One hundred and thirty-five men died and 102 were wounded on the French side. Just nineteen died and fifty-one were wounded from the *Amethyst*.

In July 1809, the *Amethyst*, commanded by Sir Michael Seymour, had recently created a Baronet for defeating a vastly superior French force in the form of a 40-gun ship. The *Niemen* was dispatched in a fleet of 246 men-of-war to destroy French ships in the Schelde and to demolish the docks at Antwerp. The fleet was backed up by 400 transport ships under the command of the Earl of Chatham. It succeeded in capturing Walcheran Island after heavy bombardment and Flushing too. Yet, rather than remain to revel in the glory, the Earl of Chatham, said to have a greater affinity for turtle soup than combat, withdrew.

It was two years later that disaster struck at around midnight on 15 February. The ship was taking on supplies, including bullocks, to join a squadron blockading Brest. For that reason she had been moored at a single anchor, on Captain Jacob Walton's orders, in readiness to leave promptly. Witnesses at the court martial described how a south westerly violent squall had built up suddenly from a hazy afternoon. Many of the ship's crew, it transpired, had warned of being too close to shore. Lt James Jacob, like most of those questioned, blamed Walton's 'zeal' for putting 'his orders in execution', for his failure to correctly moor the ship. It was Midshipman John Bowker who first noticed the movement of lights on Mount Batten, realised a wind was building up, and ordered a second anchor to be released. The captain was called for but, according to James Butler, the Master's Mate 'by the time he came up the ship had struck.'

'It came on so suddenly that I had not time,' he said when asked why he had not alerted Walton. The Master, Robert Owen, had to be called twice before he appeared on deck. But it was too late. The *Amethyst* struck the rocks on its starboard quarter, broadside to the wind. Ships nearby could not help, even though the *Ulysses* and the *James* tried valiantly.

The *Amethyst* quickly filled with water. The crew battled for several days to save the stores, but as Walton wrote rather poetically of the Master Attendant, who helped to battle the storms, he 'persevered while there was hope, and owing to the tempestuous weather alone was his plan defeated'. The hull was lost. The *Sherborne and Yeovil Mercury* devoted half a column to the news, reporting that the *Amethyst* had fired her guns continually to call for help. Officially eight men died, but according to the newspaper, fifteen bodies washed up on the shore. One belonged to Michael Bruce, captain of the transport *James*. He rushed to the scene, but the waves were 'mountains high' and he sank with his ship. The bodies of the crew and rescuers were buried at Plymstock churchyard.

Both Walton and Owen were 'severely reprimanded' for the loss of the ship. Owen was also demoted to serve as Master of any vessel 'no larger than a sixth rate' for twelve months.

Church Rocks

One summer day in July 1975, Simon Burton, a thirteen-year-old boy out spearfishing off the Church Rocks in Teignmouth, came across something unexpected. It wasn't amphibian.

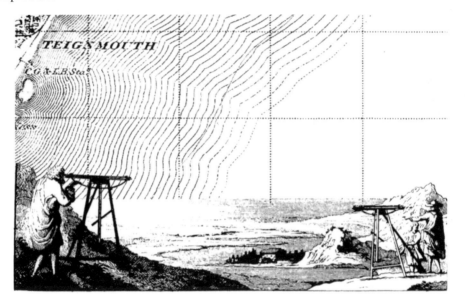

'I'll never forget that day,' he told *Triton* magazine. 'It was a brilliant summer's day, the water crystal clear, but I searched in vain for fish. As I was about to give up, I suddenly saw what appeared to be a lamp post sticking out of the sand.'

He took another deep breath and dived down for a closer look. He found that there were 'two lumps of metal attached to its sides'. In a moment of great excitement, he realised it must be a cannon. He rushed home to tell his father only to find his discovery dismissed as ludicrous, a product over an overactive child's imagination. But Simon would not be fobbed off. To humour his son, Philip told him to return to the site and rub the object's surface. If it was 'black or silvery' then it was iron and not worth their while. However, if it came out 'yellow or golden' then it would be bronze and definitely worth 'recovering'.

The pair returned to the site, but because Simon did not then know about how to take bearings from the land, it took a suspenseful few hours to find the cannon again. 'I resurfaced and threw two hands high in the air to signal to my father on the beach that it was, after all, made of bronze.'

In fact, it was a 3.4-metre bronze saker weighing over 1 tone and, still primed with powder, an iron ball in the breech and a wooden tampion in the muzzle. (A saker is a medium-sized cannon, slightly smaller than a culverin – the French version of the saker was known as the *moyenne*. They were in common usage in the sixteenth century.)

There was an impressed weight engraving on the barrel, together with a coat of arms punctuated by three rosettes and six petals. The maker's initials, S. A., were also visible. The Burton family had just found a rare gun cast by the Alberghetti family, who famously operated foundries in Venice between the fifteenth and eighteenth centuries.

This particular gun was made by Sigismundo Alberghetti II (1539–1610). The Burtons continued to search the area and for the first year turned up little other than the remains of a Second World War aircraft and an American army boot (which they initially had believed, or hoped, to be Elizabethan).

Then, in 1977, they found a Venetian minion with its carriage, a bronze swivel gun and a number of stone cannonballs. The site had become too important to leave to potential looters, so the Burtons asked the government to protect it by law. For several years they continued their work, now under government licence, but deep sand had returned to the gullies. The Burtons were becoming discouraged. They had little cash to continue working and the depth of sand was a growing problem. 'Something drastic had to be done,' Simon explained. After some research they bought a fire engine pump, capable of delivering 400 gallons a minute, and converted this into a water dredge to great success. They found the machine capable of digging a 2-metre-deep hole through the sand in ten minutes.

With their new tool, in the spring of 1980, father and son began to find more artefacts – knives, a large iron anchor, a pewter mug and another bronze swivel gun with a wrought iron breech. A few months later, they found a further bronze cannon, similar to the 1977 find, but without its carriage. A total of six guns have now been recovered from the site, along with a saker, two minions and three swivels.

Other finds included a number of copper alloy objects such as a cooking pot, a caulking pot, a lead sounding weight and plenty of ships' tools, among them an iron

adze, a hammer head, two iron knives, a wrought-iron hook, ship nails, ordnance parts and a range of ceramics.

As the excavation work continued, the Burtons worked closely with archaeologists, including Margaret Rule who brought expertise from working on the excavation of Henry VIII's *Mary Rose* off Portsmouth. Like detectives, they worked hard to find more clues to the ship's origins. The divers were lucky to find much of the ship structure itself hidden beneath the sand: part of the stern and the lower starboard section of the hull.

However, mystery still surrounds this ship. The timber, oak and its construction type, alongside the other amassed clues, the cannons and the earthenware, all indicated that this was a defensively armed merchant vessel of Mediterranean origin, most likely Venetian, built sometime after 1582. Her guns have close parallels to those found on *La Trinidad Valencera*, a Venetian merchant vessel that had been requisitioned by the Spanish for use in the Armada, found wrecked off Derry in Ireland. Some Chinese Ming porcelain was found on both vessels, yet only small amounts. Ming was quite

common among Spanish traders in the later seventeenth century, but rather rare at the close of the sixteenth century. Perhaps this suggests a wealthy merchant with expensive tastes, as the quantities were too small to trade.

We know that she would have been either a galley, powered by up to 300 slaves, or a sailing vessel. Venetian trade to England's South Coast was at the time common. Ships carried silk and spices, and would return with wool, hides and often tin. Possibly the vessel was blown off course by a storm, but specialists are still puzzling over how a wreck with such valuable pickings can have not left some kind of documented trail.

Many of the finds can now be seen at Teignmouth museum, while the saker is at St Mawes Castle in Cornwall. One of the swivel guns is in the tower of the London Armoury collection.

Mewstone Site

The Mewstone rock is set into Wembury Bay, in a wild, unprotected section of coast between the Yealm and Plymouth Sound. The rock itself is barely 2 acres, set on a steep, rocky slope, separated from the mainland by just half a mile of treacherous water at high tide.

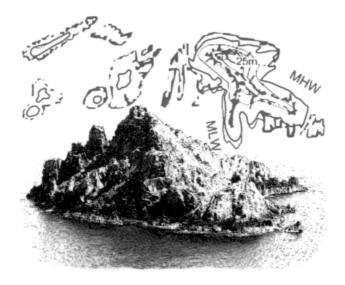

 Yet in 1776, this inhospitable landscape became the unlikely prison of a farm labourer and convicted thief for a term of seven years. John Vening was lucky, for this year marked the beginning of the American Revolutionary War. English courts, accustomed to ship their criminals to the colonies, most often Virginia, for seven years of hard labour, had nowhere to send their convicts. The magistrate sentencing Vening believed he was being lenient. Convicts in prisons or floating hulks had negligible life expectancies among the squalor and diseases.
 Vening was ordered to not set foot on land for the term of his sentence else he would be hunted down and killed like a wild animal. Despite the apparent likelihood of starvation on the Mewstone though, Vening, and his wife Molly who accompanied him, made good their exile living on crops gifted from well-wishers, blankets and tools sufficient to build a house with ship timbers washed into the rocky gullies. It is said that after seven years, the pair, with their children and later grandchildren, moved to Looe Island off Cornwall where they lived comfortably off payments from smugglers hiding their loot from the Royal Navy's revenue men.

It is not known whether Vening or his family witnessed any shipwrecks, but it is highly probable. The Mewstone was an unlikely prison, but a fatal magnet for shipping in a storm. Although mariners have used St Werburgh, Wembury's church, high on the rocks overlooking the Mewstone, as a landmark since the fourteenth century, many others have lost their lives here when their ships came crashing in. At low tide, the depth around the rock can reach as little as three metres; but only if you dive in would you realise the full extent of the damage the rock has claimed over the last three centuries.

The first ship known to have wrecked on the Mewstone's ragged shores was an eighteenth-century armed merchantman. Steep sided rocky gullies conceal ten iron cannons lying almost in a straight line as if they had been dropped to lighten the vessel to prevent its wrecking. Also scattered among the wreckage are two large anchors, and most interesting of all, a dense scattering of pink earthernware, including groups of distinctive neck and shoulder sherds of large oil jars. These containers were in common use in Europe and its colonies from the 1740s to the early twentieth century. They have been dated to the second-half of the eighteenth century by the specific plaque, potentially the same period as our prisoner. One of them bears the raised initials I. F. with a stylised crown, most probably a merchant's mark. These initials were common on jars from Wapping, east London and towns further east like Colchester. Archaeologists were able to piece together seven jars, which suggests the cargo was probably in transit rather than being used as water containers. While their shape is fairly similar everywhere, evidence suggests that these particular jars were made in Tuscany and Portugal, indicating a well-travelled merchantman.

This eighteenth-century wreckage is not, however, alone. This site is rather complicated by the fact that at least three other ships are known to have been wrecked in the very same spot. The paddle steamer PS *Ajax* came crashing into the rock on 13 October 1854, despite the flat, calm sea, carrying a cargo of 400 boxes of tea and 61 tons of guano, whose uses ranged from fertiliser to nitrates for gunpowder. All 350 passengers, many emigrants bound for America from London via Cork survived, thanks largely to the courage of chief petty officer Steel, who, armed with a stick, calmed the panic aboard, but also to the small flotilla of boats that came out to help from land. One passenger was so frightened by her experience, she went into early labour on land and gave birth in the harbourmaster's office at Millbay.

Suspicion for the wrecking in such clear weather fell on Captain Rochford, who was accused of culpable negligence. Salvage was attempted – the cargo itself was said to be worth £10,000 – but the divers were forced to turn back. Ironically, it was only after the wrecking that a tremendous north-westerly wind blew up that lasted over a week. By the time it settled, there was little hope.

The *Jane Matilda*, a small fishing boat, was the next recorded wreck twelve years later. The vessel sank instantly and two of the crew drowned. Then, on 15 October 1877, SS *Rothsay*, a 332-ton steamer, was returning in ballast from Caen to Cardiff when she met a hurricane and aimed for Plymouth for shelter. Yet as the winds grew wilder, the captain realised his ship was lost and that only divine power could help him. Within minutes of midnight, in tempestuous seas, she smashed into the rocks surrounding the Mewstone. The force of the impact threw one of the crew off the ship. Amazingly, his landing was softer than expected and he was able to reach the Mewstone, from where he managed to throw a line to his crew members.

The Mewstone still holds many secrets. A bronze astrolabe, one of earliest navigation tools designed to determine latitude, was found by a diver on the lee of the island. This one was dated to the seventeenth century. No wreck has ever been found.

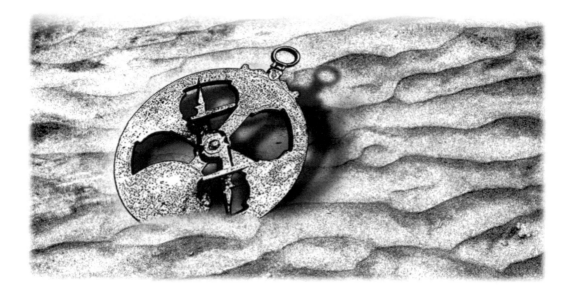

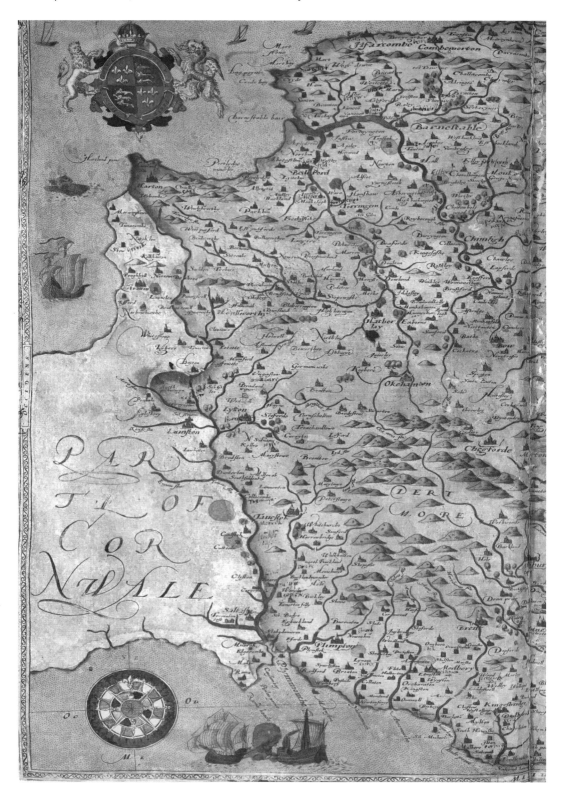

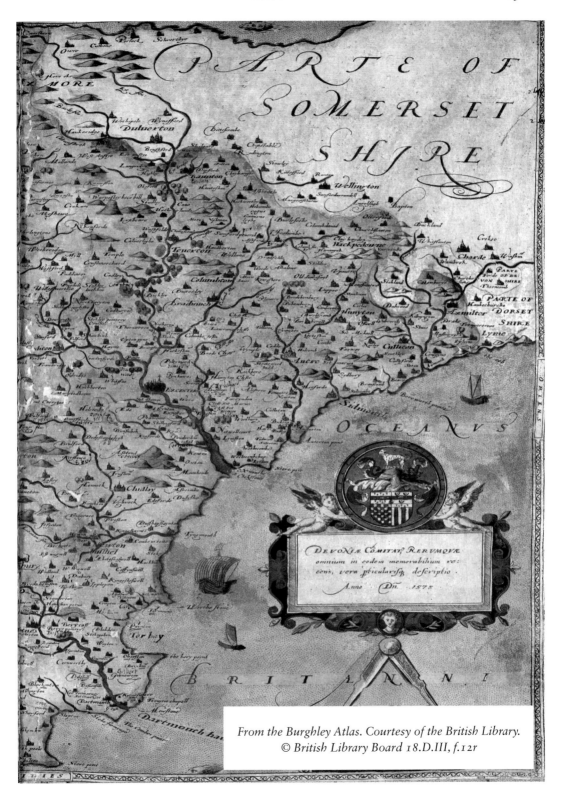

San Pedro el Mayor

The *San Pedro el Mayor* is one of only two Spanish Armada ships known to have been wrecked off England. An urca, a wooden hulk vessel, she was wrecked in Bigbury Bay near Hope Cove, though she has never been found. She was a hospital ship, part of a squadron of urcas commanded by Don Juan Gomez de Medina. The 581-ton vessel was lightly armed with just 29 guns and carried between 100 to 200 soldiers.

Part of the first wave of the Armada, the *San Pedro el Mayor* witnessed the fatal explosion aboard the *San Salvador* on 31 July off Plymouth, the only other Armada ship to have been wrecked off England. Being nearby, she accepted thirty-four of the wounded and stayed in the area taking on more injured and sick as the battles in the

English Channel raged. At one point, she arrived in Calais following a rout by English fire ships. Eventually chased off, the *San Pedro el Mayor* circumnavigated Scotland and Ireland, trying to shake off her pursuers and landed in Vicey, a small harbour by the Great Blasket Sound off County Kerry. There she met the commander of the *San Juan de Portugal*, Vice Admiral Juan Martinez Recalde, already one of Spain's naval heroes. The captain, Pedro Coco Calderon, failed to reprovision the *San Pedro el Mayor* and left with yet more sick and wounded, together with the *San Juan*. Weak with thirst and hunger, his crew were at pains to control the hospital ship. Calderon set sail for Cadiz and home, but a south-westerly gale picked up too suddenly and on 5 November 1588, drove his ship straight into Bigbury Bay, where she ran onto the rocks. Days of gale force winds reduced the ship to matchsticks. Little could be done, stated one witness: 'the ship is not to be recovered. She lies on a rock full of water to her upper decks'. The locals followed tradition and eagerly pillaged the vessel, taking what spoils they believed their due, which included some 6,000 ducats worth of drugs and some 'brass pieces'. They were dismayed though that the ship itself contained little else of great value: 'the ordnance is all iron and no brass.'

The real prize, however, was the instant free labour in the form of Spanish prisoners, who, as a result, escaped execution. The number of crew, soldiers and hospital personnel appear to vary with each reference, sometimes stated as 30 mariners, 100 soldiers and 50 staff. According to some sources, the captured included 123 Spaniards, 10 French, 10 Dutch, 2 Italians and 13 Portuguese.

A squabble erupted between two noblemen, Sir John Gilberte and George Carey. Gilberte, Carey argued in a letter to the Privy Council, was greedily claiming the prisoners while pocketing their 4d per diem. Carey, on the other hand, suggested taking only 2d for himself. The outcome is not known, but it is certain that the local gentry saw an ideal opportunity for making a little extra money: a letter some days after the wrecking refers to a significantly greater number of prisoners than an earlier list. Carey, it transpired, was more eager for skills than extra funds ('John Gilberte having disposed already of all the best') and succeeded in housing the ship apothecary and a sergeant, both of whom had far greater knowledge of medicine than had been seen for some time in South Devon. Some twelve prisoners 'of the best sort' (wealthy), were taken by Sir William Courteney at nearby Ilton Castle where they were able to await the payment of their ransom while their 'wants' were provided for.

Two years later, the Duke of Parma sent a commissioner to ransom the general prisoners, much to the dismay of Courteney's men, for whom he did not pay, arguing that they had been given away by Queen Elizabeth. Salvation for one of them, at least, came some months later in the form of a Biscay captain called Domingo Ochoa, who dispatched an envoy to England to say that he had been sent on behalf of the Duke of Mercoeur to ransom them, in particular Friar Rodrigo Calderon and Alvaro Castro.

Courteney, aware of the potential sums involved, released one prisoner who, on meeting the Duke in Nantes, delivered a letter from Courteney asking for 20,000 crowns for the rest of the prisoners, 100 for captains, 50 for ensigns and 15 to 20 for other officers and soldiers. The outcome is not recorded.

The Village Inn in Thurlestone claims to be built of some of the timber remains of the wreck. No-one has attempted to dash this boast despite the pub's construction date of 1777, some 200 years after the event.

HMS *Ramillies*

It happened to be on a certain day
A ship, the Rambeler, at anchor did lay;
The very night the gale came down
She broke from her anchor and away she did go.

Oh, the rain pouring down was a dismal sight,
The sea running high over our foretop;
We had some canvas that was neatly spread,
Thinking we could weather the old Ram Head.

'A boat, a boat, my good fellows all,
And ready to answer when I on you call.
Come launch your boats your lives for to save,
I'm afraid this night the sea will be your grave.'

The boats they were launched and in the seas were tossed;
Some got in, but soon were lost.
There were some in one place and some in another,
And the watch down below they were all smothered.

Now when this sad news reached Plymouth town,
The loss of the Rambeler and most of her men,
There was only three that could tell the tale,
How our ship did behave in that dreadful gale.

Some come all you pretty maids wheresoever that you be,
The loss of our true loves in the Rambelee;
For Plymouth Town it flowed with tears
When they heard of the sad and dread affair.

The wrecking of the *Ramillies* inspired a number of laments. This one, the *Wreck of the Rambeler*, was written at the time of the wrecking, and has been put to a variety of tunes.

The wrecking of the HMS *Ramillies* on 15 February 1760 was the greatest disaster in Royal Naval history. The *Ramillies* was a second-rate, 90-gun ship carrying 734 men. The ship had an unusual number of reincarnations. She was launched in 1664

as the *Katherine*. In 1702, she was rebuilt and renamed the *Royal Katherine*, before finally undergoing a new refit and renaming to the *Ramillies* in 1749.

In her final guise, she was involved in many battles of the Seven Years War. In 1749, she was Admiral John Byng's flagship at Minorca. Byng failed to relieve Port Mahon and so lost the island. He was executed for cowardice following a court martial on the quarterdeck of his ship. Voltaire noted in his novel *Candide*, '*Dans ce pays-ci, il est bon de tuer de temps en temps un amiral pour encourager les autres*'. (In this country, it is wise to kill an admiral from time to time to encourage the others.)

In 1760, she was ordered to join the rest of the fleet at Quiberon Bay. She had missed the successful defeat of the French at the Battle of Quiberon Bay three months earlier because her admiral, Sir Edmund Hawke, had ordered her to return to Plymouth to repair leaks. (The *Ramillies* had been Hawke's flagship, but he had had to swiftly transfer his flag to the *Royal George* just before the battle.)

Her fleet commander this time, on the flagship the *Royal William*, was Admiral Edward Boscawen. The fleet, which included HMS *Sandwich*, HMS St *George*, HMS *Princess Amelia*, the frigate HMS *Venus* and the cutter HMS *Hawke*, left Plymouth in early February. As they progressed eastwards, the south-westerly wind was freshening noticeably. Boscawen was moved to note that the gale was 'so violent I could seldom carry a topsail'.

The *Ramillies* was feeling her age. The alleged repairs at Plymouth were scarcely holding and leaks were beginning to appear. Her captain, Wittewronge Taylor, ordered the lights to be readied and the guns prepared to signal distress. But these were never fired. Taylor was concerned that they might appear to be coming from the Admiral's ship. He gave the order to distance the *Ramillies* from the rest of the fleet.

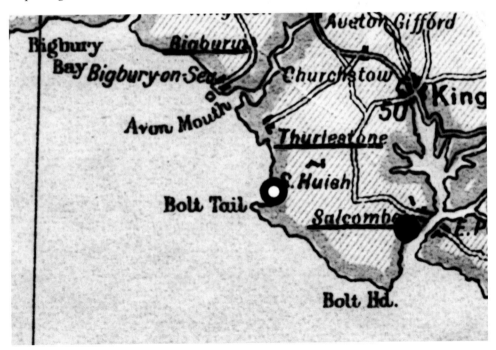

By 14 February, the south-westerly wind had turned into a 90-mph gale. The crew could no longer keep the pumps working. The ship was been tossed from peak to trough with no longer any semblance of control, when suddenly a midshipman, John Harrold, shouted 'Land Ho!'. All on deck looked to the port bow, and sure enough they could make out land. Taylor was relieved. If the island was Looe, that meant they were not far from Plymouth and shelter. Some 30 minutes later, the ship's company could see cliffs 100 metres high looming above them. *This must be Rame Head*, thought Taylor.

But he was catastrophically wrong. Rather than being on the western approaches to Plymouth Sound, the *Ramillies* was trying to go round Bolt Tail from Bigbury Bay, one of the most treacherous headlands along the South Hams coast. The island they had passed was Burgh Island. Immediately, Taylor ordered the main sheet let go. At two o'clock he ordered the foremast to be chopped. The action knocked out the bowsprit at the same time. His crew released anchors to try to hold the ship from the cliff. It was not long before these parted under the vicious pull of the gale.

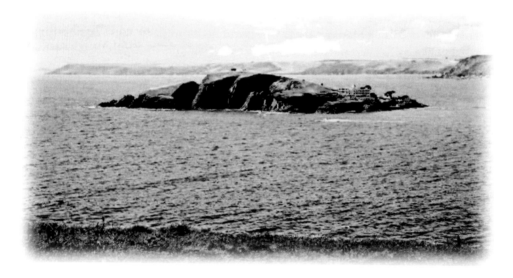

By this time, a crowd had gathered above. One of their number described what he had seen in the *Gentleman's Magazine* later that month:

It blew a hurricane, by which much damage was done both at land and in the river ... At sea it did incredible damage to the shipping; in almost every harbour some persons perished in boats and in ships; but the loss most to be regretted is the loss of the unfortunate Ramillies, Capt. Taylor, with 734 men. Being embayed within the Bolt-head (which they had mistaken for Rame Head, and imagined they were going into Plymouth Sound) and close up on the rocks, they let go their anchors, and cut away all their masts, and rode safe till five in the evening, when the gale increased so much it's impossible to describe; they parted and only one midshipman and 25 men out of the whole jumped off the stern on the rocks and were saved.

Bowscawen too, stated that 'from the hour of two in the afternoon, it blew stronger that I ever felt it in my life'. The song above – *The Wreck of the Rambeler* – composed at the time of the wrecking, adds some flavour to the catastrophe. The captain of the marines reportedly went mad and was last seen pacing the deck singing poetry. The boatswain, who had brought his young son aboard, thought he could save him by throwing him clear of the ship. But his action ended in tragedy. The boy landed directly onto the rocks and his head was crushed. Most died from their injuries or from drowning. The heavy, grey light the following morning revealed a mass of wreckage and hundreds of bodies washed into the narrow, jagged inlet and into the bays around the headland.

'The ship is drove to such pieces that it appears likes piles of firewood,' Boscowen told the Admiralty in despatches.

William Wise was one of the lucky few. According to Boscowen's account, Wise was the last man to jump clear of the ship. He lowered the stern ladder and, although the ship crushed his right leg as he fell upon the rocks, he managed to haul himself half way up the cliff where he collapsed before being rescued the following day. The hollow in which he sheltered is now known locally as 'Wise's Pit'.

Harrold, the midshipman, was the only officer to survive. The hollow, unsurprisingly, can be reached by following 'Harrold's Path'. Harrold waited half an hour on the rocks to see who else might emerge from that wild sea, before making an arduous 22-mile trek to Plymouth alone to tell of the tragedy and look for help.

While the twenty-six survivors gave their accounts, many from sickbeds in the local village inns, the Admiralty busied itself in trying to prevent the 'Country People from plundering his Majesty's stores'. Soon after, it dispatched eight men to salvage as many cannon as they could by hauling them up the ragged cliffs – a process that took far longer than hoped. The labourers were held back by sickness brought on by relentless hail, rain and snow.

SS *Persier*

The *Persier*, one of the last ships to be torpedoed in the Second World War off the UK, was a Belgian steamer ship carrying much needed supplies (2,400 tones of soap, 1,400 tones of dried egg, 1,000 tons of unspecified meat and 20 tones of general provisions) to the recently liberated Belgium from Cardiff on 11 February 1945. (Originally a British ship built in Howden-on-Tyne as the *War Buffalo*, she was sold to Belgium in 1919.) She was also carrying 51 Belgian survivors from the torpedo attack on the troopship *Leopoldville* off Cherbourg on Christmas Day, two months previously, when 783 died.

The wind was close to gale force and the seas were high. The convoy commander, Commodore Edmund Wood, was 4 miles south-west of the Eddystone lighthouse, off Plymouth, when one of his convoy sighted a torpedo. Seconds later, there was an explosion, just 200 metres off Persier's port beam. A torpedo had exploded prematurely. A second torpedo followed, passing under the *Persier*'s stern.

Then there was nothing. The Master, Mathieu, and Wood knew that they could do nothing but wait. A full five nerve-racking minutes passed before the *Persier* received her inevitable hit. The torpedo struck the second hold just ahead of the bridge on the port side. First Officer Lardinoy was flung hard on to the deck and broke his nose. U-1017 slipped away and later reported hitting two ships. She believed that the first torpedo had also hit her target.

As the *Persier*'s bows began to slowly submerge in the heavy seas, her stern rising up, her cargo of food and blankets slowly dispersed like so much jetsam. Wood ordered the ship to be abandoned, but the evacuation went horribly wrong. The engines were dead, or so it seemed. Just as lifeboat number three landed in the water, however, it was sucked into the *Persier*'s propellers, which were jutting out just above the waterline. The shock waves from depth charges, dropped almost as soon as the *Persier* abandon ship effort had begun, caused the engines to restart themselves.

Lifeboat number one failed to detach itself correctly in the high seas. All ten on board, including the commodore, were thrown into the sea. The survivors wrestled for what seemed like hours to right the raft. The stoker, who had slid down the ropes to get to it, caught his ankle and was left swinging upside down, his body banging against the ship. Two others who managed to right it were sucked into the turning propeller.

British coasters, *Birker Force* and *Gem* arrived at the scene, but it was up to Lardinoy to attract their attention. Recognising that without being signalled the two vessels would not approach, Lardinoy was forced to swim to a raft belonging to the *Birker Force*. Fearing that he too would be sucked into the propeller, he asked the remaining men aboard to throw him as far as they could into the water. The mission was a success. The two coasters moved in, giving the remaining men on the *Persier* the courage to throw themselves into the sea, knowing they would be rescued, by which time HMS *Cornelian* also arrived on the scene. The *Persier* sank under tow in Bigbury Bay that night.

In all, forty-three survivors were picked up out of the sixty-three known to have been aboard. Both Wood and the signaller, John Phillips, were lost in the attack. U-1017 was sunk off the north-west coast of Ireland on 29 April. The *Persier* is now a popular diving site, due in part to its position in relative proximity to the shore and shelter from the wind.

HMS *Stockforce*

HMS *Stockforce* was torpedoed by UB-80 in 1918 and sank just a few miles off Bolt Tail in the entrance to Bigbury Bay.

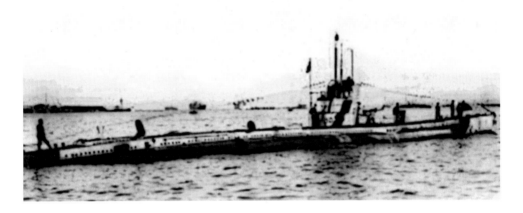

In the subsequent inquiry into her sinking, the commander in chief at the Admiralty declared that the incident was one of the 'most remarkable accounts in the whole history of S.S. [Special Service] Vessels' for which her captain received the Victoria Cross, the highest medal for gallantry.

The *Stockforce* was a decoy, disguised ship, a Q ship, whose mission was to sink U-boats. The Q ship's appearance as a dilapidated merchantship would lull her prey into a false sense of security. Once within a 300-metre range, she would fire her guns.

Her story began on 30 July 1918. Lt Harold Auten, a dashing twenty-six year old, was in command. *Stockforce*, a 360-ton steam collier, had just been converted to a Q ship at Queenstown. Her holds had been stuffed with timber to ensure she would float as long as possible after being hit (an innovation of Auten's), and a false mizzen mast and a dummy boat had been added to the disguise. Most importantly, she was well armed with two 4-inch guns, one 3-pounder, two 14-inch torpedo tubes and two 12-pounders, though her weaponry was invisible, hidden behind panels. Her outward appearance was still that of a steam collier. Her false mast and boat were ditched once they had safely left harbour. The subterfuge had had to begin even in friendly waters, because only recently a Q ship had been torpedoed just four hours out of Haulbowline Dockyard. Spies had been suspected. Bogus orders were issued and *Stockforce* weighed anchor two days ahead of schedule.

Acting on a wireless signal, she changed course for the Lizard in Cornwall: a U-boat had been spotted working on a line between Guernsey and South Devon. By taking this course, she would hopefully appear to be returning to Cardiff to collect more coal for French ports. French spotter aircraft buzzed overhead, much to Auten's annoyance. While they believed they were assisting the collier, they only served to irritate the captain who was attempting to steer into danger rather than flee it.

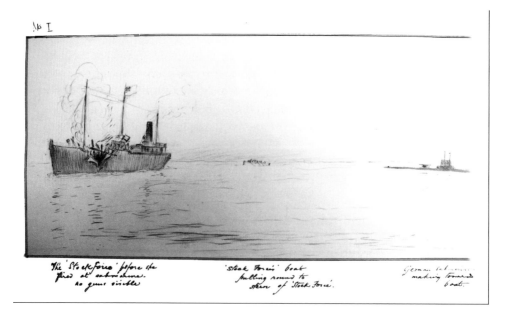

No I

The 'Stockforce' before she
fired at ambush line.
No guns visible

'Stock Force' boat
pulling round to
stern of 'Stock Force'.

German sub......
making towards
boat.

When the torpedo struck, the damage was severe and appeared to lift the ship up and throw her body to port. Auten recalled seeing the track of the torpedo about 500 metres off. He immediately turned hard to port, but the torpedo struck the starboard bow, hitting the athwartship bulkhead, pushing it through to the starboard side. At

the same time, he was blown into the air from the bridge where he had been standing and landed underneath the chart table. One gunner, Officer's Steward 2nd class Reginald Starling, was trapped under the forecastle 12-pounder gun and would have to remain there until the submarine had gone. After crawling out, Auten made his way

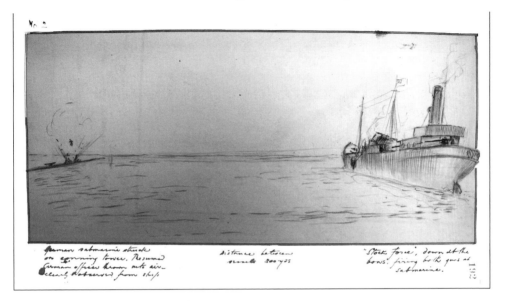

to the lower decks to see the extent of the damage. To prevent the roof caving in, and revealing their panels were a mere disguise, three men had to prop it up with boat oars. The Germans still then had no way of knowing the real identity of their prey. Auten had to keep up the pretence of a fatally damaged merchantship, assembling a 'panic (abandon ship) party' of twelve men, taking care to include his one black crew member. His presence, he felt sure, would confirm the Germans' expectations that they had hit a merchantship. Black men were a rarity in the Royal Navy at this time.

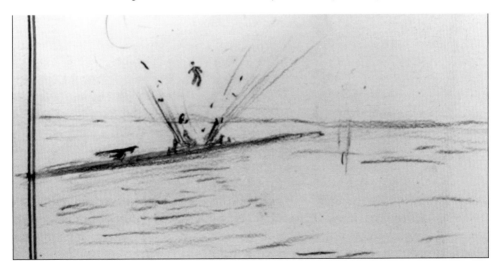

The 'panic party's' aim was to draw the submarine closer to the *Stockforce*, to bring it within range and bearing of her guns. UB-80 sat stationary half a mile away for around twenty minutes observing the 'panic party' making its escape. It then began to close in. On seeing this, the ship's boat began to pull away down the port side towards the stern to draw the submarine further in. After carefully studying the men in the boat, UB-80 came slowly round to within 300 metres of the *Stockforce*. At that moment, Auten gave the command to drop the disguise hatches, run up the White Ensign and open fire.

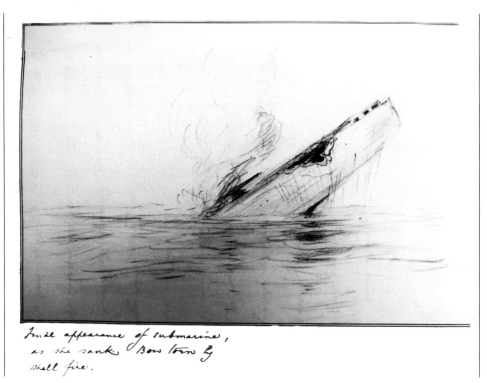

Final appearance of submarine, as she sank. 'Bow torn by' shell fire.

The first round hit the submarine's aerial above the conning tower. The second hit the conning tower in the centre, blowing it away. Only one person was in it and he was blown high into the air. The next round hit the waterline beneath where the conning tower had been, blowing many of the crew out, fore and aft. A blue plume of smoke began to stream from the submarine after which the *Stockforce* fired shell after shell until the UB-80 sank from the stern almost immediately, leaving a pool of debris on the surface.

Auten then recalled his twelve men and made all speed ahead to try to reach closer to shore as the Q ship was listing badly and awash with most of the starboard side below water. Meanwhile, he set his crew to making a couple of rafts out of the remaining timber, as there would be insufficient room in the ship's boats to get everyone ashore. Starling was finally released from beneath the forecastle gun where he had lain trapped since the beginning of the operation. Amazingly, he suffered only the loss of three teeth,

a punctured lip and a badly sprained arm. A trawler, *Kumu*, and two torpedo boats, having heard the firing, arrived quickly on the scene and rescued survivors. Auten and the 1st-Lt Edward Grey who had received a head wound in the initial attack, were the last to leave the ship on a dinghy, but not before the ship's surgeon George Strahan had located the confidential books, locked them in a steel chest and thrown them overboard.

Many awards were bestowed on the crew of the *Stockforce*. Of the forty-four men aboard, twenty-three received medals or were mentioned in desptaches. Five of those, including Grey and Strahan, received the Distinguished Service Cross. Auten himself received the highest medal of all, the Victoria Cross. The ship received a £1,000 award, to be shared amongst the crew.

It later transpired that UB-80 had not sunk but had dived, suffered minor damage (two broken periscopes) and made it back to a German port, though not before attacking an 8,000-ton ship escorted by two destroyers en route. The torpedo, however, failed to explode.

UB-80 surrendered in November in Italy. Auten, elevated to Lt-Com., moved to America after the war and wrote and starred in several films. In one, a silent film, *Q ships*, he played himself.

(The four Stockforce images are courtesy of National Archives, Kew)

Herzogin Cecilie

This wild stretch of coastline is no stranger to shipwrecks, but when the *Duchess*, as she was fondly known, crashed dramatically into the cliffs of Soar Mill Cove in 1936, the news inspired some 50,000 people to visit the coastal beauty spot, causing mile-long tailbacks. The 'treacherous mystery of rocks' had claimed one of their most famous victims.

The *Herzogin Cecilie* was named after Cecilie von Mecklenburg-Schwerin, the Duke of Oldenburgh's daughter and wife of Kaiser Wilhelm II. She proudly bore a figurehead carved in the duchess's image. As in life, her slow death befitted the legend that surrounded her. Capable of breathtaking speeds (just a quarter of a knot below the record at 21¾ knots), the *Duchess* captivated the public's imagination as the finest merchant ship afloat, second only to that famous tea clipper, the *Cutty Sark*. But it was a combination of her standing in the world and the romance of the human story that brought the crowds down that summer. When she crashed into the rocks on the foggy night of 26 April, the first the coastguard heard was a foreign voice from the rocks below shouting 'where am I?' Three months later, the wreck had become a major tourist attraction. Canny landowners were charging a penny to park and cross their land. The police were called and, in an effort to reduce the crowd crush, introduced a one-way system and local shops hailed this the 'Cecilie summer'.

The crowds had initially been drawn not just by the dramatic wrecking. The romantic tale of the skipper and his wife had also inspired them. The thirty-two-year-old captain and his wife initially refused to leave their 'honeymoon' sinking ship, reported the *Sunday Despatch*. 'For ten hours her young captain, Sven Eriksson, and his bride, with their pet dog, stuck to the doomed ship, after a lifeboat had taken ashore 23 of the crew and an English girl passenger.'

Built at Bremerhaven in Germany in April 1902, the *Duchess* began her career as a German training ship. She was a four-masted steel barque with auxiliary steam power, and spacious, even luxurious, accommodation for the standards of the day. During the First World War, she was interned in Chile. At the end of the war, she was granted to the French as part of war reparations and then in 1921, having spent some years slowly deteriorating in harbour, she was sold to a Finnish company and used as a grain transporter. (The new owners found that the Germans had attempted to steal some of the ship's more valuable equipment and sabotaged cooking utensils. This included holing cooking pots and damaging radio wires.)

The Duchess completed her last ocean voyage from Port Lincoln in South Australia in just eighty-six days, helped by strong south-east trade winds and a good Atlantic westerly, which landed her in Falmouth. It was there, though, that the Duchess's luck appeared to be running out. As she pulled in on 23 April, she was 'arrested' because she had earlier collided with and damaged the Rastede, a German trawler in the Kattegat. Paying the bail fee, Eriksson set sail the next day, impatient to reach his last port of call – Ipswich. Shore leave, however, took its toll on some of the officers who reappeared in time to sail 'not completely sober … but … not staggering', noted one of the crew. The captain's mood had darkened. He needed to make up time for the day lost in port. But he'd found a solution: if he plotted a route on the charts which brought him far closer to land than the usual way along that stretch of coast, he could shave off some hours by avoiding what was known as the 'steamers' route' on account of the heavy shipping traffic.

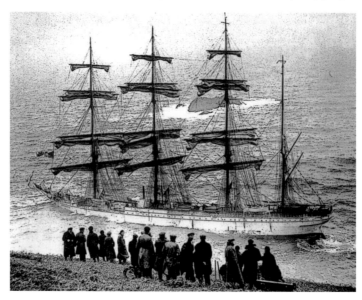

At 4.05 a.m. on 25 April, the *Herzogin Cecilie* hit the treacherous Ham Stone rocks off Soar Mill Cove like 'we'd hit a wall', recounted one of the seamen, Peter Hjelt. He could not recall seeing the captain on deck once until the accident, and 'I do not say that the officers were completely sober'. Indeed, while most of the ordinary seaman were on deck, the officers were drinking and celebrating in the saloon that night.

The crew fired flares into the night, which were spotted by the coastguard lookout at Steeple Cove. 'Ship ashore!' he cried. Coastguards regularly patrolled the coastal paths on foot at night, marking distances with rocks painted white so that they could be seen more easily at night. Within minutes, the *Alfred and Clara Heath* lifeboat had been launched.

The drama continued through the early hours until about midday. It was too late to save the valuable cargo. The grain that had begun to swell burst through the decks.

The owner, Gustav Erikson, was inconsolable, comparing the feeling of desolation to that of the loss of a family member. He was furious with the captain for taking the irresponsible shortcut, especially during thick fog. His wife, he added, had taken the news very badly. 'Her nerves are broken and she is now in bed, since H. C. was everything to her, she can speak of nothing other than the great loss.'

Attempts were later made to save the ship. On 19 June, she was towed from the rocks to Starehole Bay in the mouth of the Salcombe estuary, which unbeknown to the volunteers, had a rocky base beneath the sand. (Originally she was to be towed into Salcombe itself, but locals feared tourists would be deterred by the pungent smell of rotting wheat.) The following month, a south-easterly gale finished the ship. What could be salvaged was sold for £225 to scrap metal merchants, Noyces of Kingsbridge. The wreck itself can sometimes be seen from the cliff top above during the extreme lows of spring tides.

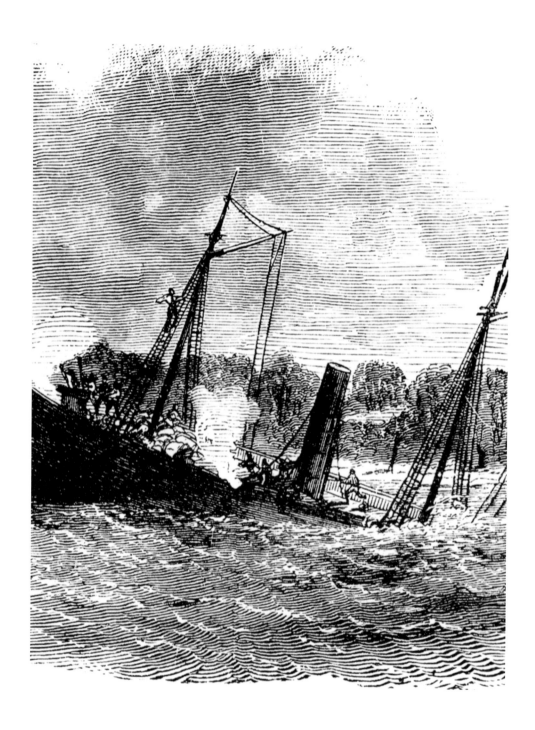

William and Emma

SUNSET and evening star,
And one clear call for me!
And may there be no moaning of the bar,
When I put out to sea,

But such a tide as moving seems asleep,
Too full for sound and foam,
When that which drew from out the boundless deep
Turns again home.

Twilight and evening bell,
And after that the dark!
And may there be no sadness or farewell,
When I embark;

For tho' from out our bourne of Time and Place
The flood may bear me far,
I hope to see my Pilot face to face
When I have crost the bar.

Crossing the Bar, by Alfred, Lord Tennyson

The Salcombe sandbar that crosses the mouth of the estuary has been responsible for many wrecks. Some ships have mistimed the tide, others, brave or too foolhardy, have attempted to charge it, and others still have been violently swept upon it.

It is claimed variously that Alfred, Lord Tennyson wrote his poem, *Crossing the Bar*, in 1889, whilst moored on a yacht at Salcombe, or staying on land at a house called the Moult, recuperating from an illness. The poem compares 'crossing the bar' to crossing into the 'boundless deep' of death, where he meets his 'Pilot face to face'.

In 1869, after centuries of shipwrecks attended sometimes by the coastguard, and not always well-meaning locals with an eye on some means of swift remuneration, Salcombe got its first lifeboat. The station was an immediate success. Only one particularly gory incident, involving a frenzied knife attack, marred its history. Following an evening in a pub at Prawle in December 1871, a recently rescued Italian crew member from the *Marie Tereza* turned violent, grabbed a knife and began lashing out at people, stabbing many drinkers. Even the duty coastguard, called because the village had no police, was attacked. All the victims survived, however. The quarrel was quickly forgotten, the locals being accustomed to their powerful liquor's effect on strangers.

The real tragedy took place on 27 October 1916 and scarred the town: a monument to the memory of the thirteen lifeboat men who died crossing the bar that morning on the *William and Emma* is testament to their bravery.

The Liverpool class vessel was a 10-metre, 12-oared boat. Its two drop keels made it versatile: it could be moored on the beach like an oared dinghy, but also propelled under sail. That morning, a strong southerly gale was howling up the estuary. White crests were breaking hard across the bar when the *William and Emma* got the call at 5.12 a.m. Prawle coastguard was reporting that the *Western Lass*, a Plymouth schooner, was in trouble at Langerstone Point. Most men would have turned back at the bar in those conditions but the *William and Emma*, guided by the coxswain, Samuel Distin, pressed through. An audience had gathered on the shore, breathless, watching and praying, and then amazed as the little boat made it out into deep water, and turned to head east.

Just as she was clearing the final hurdle at the bar, news came through to Prawle coastguard that the *Western Lass*'s crew had managed to get ashore. The Prawle rocket company had succeeded in firing lines out to the sinking ship so that the crew could

haul themselves in. No-one was able to warn the men on the *William and Emma*, who later arrived at the scene only to find an empty and disintegrating wreck. Drenched and growing bitterly cold, they turned for home, and arrived back at the bar at around ten o'clock. By then, the gale had increased in intensity.

After a momentary hesitation, the crew decided to push on rather than wait for the wind to abate. Following a well-rehearsed training drill, they let out the sea anchor over the stern and pulled in all the sails except for the mizzen aft, and aimed straight for the bar. But just as they had completed the drill, a huge wave came under the stern and threw it up high. The *William and Emma* was hurtled broadside onto the waves and her crew were momentarily thrown on top of each other. But then, just as soon as they were clear again, another massive breaker hit the vessel beam on and capsized her. Families and friends watched helpless in horror as the spectacle played out. Some ran along the coast hoping that the crew, who were all in lifejackets, might wash up there.

A few tried to cling to the keel but were washed away, some knocked unconscious by the ferocity of the storm that engulfed them. There were only two survivors, Edward Distin and William Johnson. They managed to swim to Rickham Common and had

just sufficient energy to clamber on to some rocks, about 15 metres from the shore. (This coastal path where the two men landed had been famous for the last two and a half centuries as the spot where the Parliamentarian artillery was placed to pound Fort Charles on the opposite side of the estuary, during the Civil War in 1646.) A line was lowered to them weighted by a flask of brandy, which gave them just enough strength to cling hard to a stronger rope to which their rescuers had attached lifebuoys. Finally the pair were dragged ashore, battered and in shock.

The incident badly affected the little town of Salcombe that had already lost many young men to the Somme trenches. The graves of some of the lifeboat men are in Salcombe's Shadycombe cemetery, the others can be found in Malborough. The Salcombe station later earned the distinction of sending the last lifeboat out for service during the Second World War. That last was on 7 May 1945, when the *Samuel and Mary Parkhouse* was called at midnight to join the Torbay lifeboat in the hunt for survivors of the Norwegian minesweeper 382, which also happened to be the last vessel lost to a U-boat, U-1023.

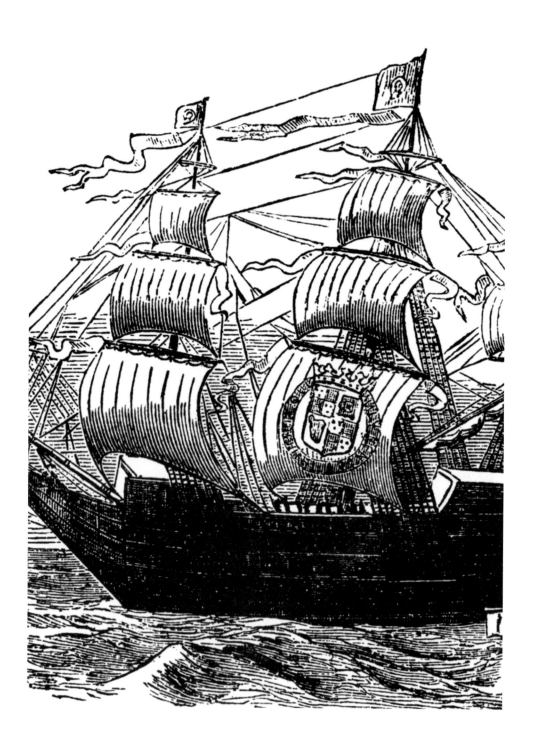

Moor Sands Sites

Off Prawle Point near Salcombe, in around 10 metres of water, lie three of the oldest wreck sites in Britain, each within metres of each other. They have lain here for over 3,000 years. It was a diving instructor, Philip Baker, who discovered the first site by chance in 1977. It has since become known as the Moor Sands site.

The bronze sword discovery, unparalleled in Britain, was not unlike material from the Seine basin in northern France. The other finds, rapiers and palstaves, are similar to those found in Brittany and are thought to be imports. The discoveries were dated to the middle Bronze Age, about 1100 BC (the same time as the siege of Troy), and suggested this could be one of the earliest shipwreck site, anywhere in the world.

Then, some thirty years later, a diver investigating a seventeenth-century site in the area chanced upon something gleaming in one of the rocky gullies. This initial discovery has now changed our understanding of the sophistication and extent of Britain's links to Europe in the Bronze Age, and the island's seafaring abilities. One of the most exciting finds, the '*strumento con immanicatura a cannone*', (instrument with cannon joint/handle, or a socketing tool) is the first ever Bronze Age object of Mediterranean origin to have been found in Britain. The strumento is a type known only to Sicily.

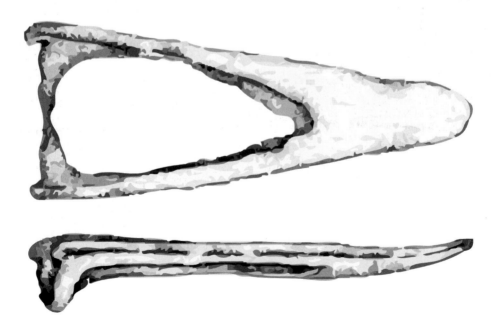

This site, now known unromantically as 'Salcombe B' to maritime archaeologists, has also yielded a number of gold items, including bracelets and twisted torcs. Sword remains have also been discovered alongside cooking utensils and a neat, rectangular bronze block. It is too neat to be an ingot, yet if it were an anvil, its small size and lack of stake attachment would limit its use.

Of the three known examples of such sites in North West Europe, this one has provided the most varied evidence of international exchanges and also the most diverse range of material present on such a site.

Yet as the team of divers from the South West Maritime Archaeological Group continued their investigations, it began to become clear to archaeologists that they were working with not one, but two extensive Bronze Age periods lying side by side, one from the middle Bronze Age, and another, far larger hoard was from the late Bronze Age.

This last realisation came in 2009 with the spectacular discovery of 259 copper ingots, and 27 tin ingots. Other finds were a bronze leaf sword and two stone artefacts that could have been sling shots. The finds were hailed by the British Museum as one of the most important Bronze Age sites currently under investigation, giving real direct evidence of prehistoric trade in tin and copper. They offer the tantalising possibility of evidence of long-distance prehistoric sea voyages, which beforehand could only be surmised indirectly from discoveries on land.

It is possible that the goods arrived via a series of vessels on short coastal hops rather than one single direct voyage. No remains have been found, though this is not surprising given the rocky gullies and treacherous coastline. Little organic material survives here. It is thought the vessels could have sunk here whilst trying to land: there is evidence of Bronze Age field systems on land above the site. There are of course other possibilities, one being that there were no vessels, but these artefacts were simply votive offerings. Far more analysis on the origin of the finds needs to be done before we can be sure.

Experts believe that a 'bulk' cargo carrier would have imported the copper, and possibly the tin into Britain, for the manufacture of bronze, from a number of different countries throughout Europe, demonstrating a complex network of trade routes. This is the first time that tin ingots from the late Bronze Age have been found in Britain. It is unclear whether they originated in Britain or if they came from the Iberian Peninsula, or potentially eastern Germany. The exact origin of copper is also unclear, although it is believed to come from both Iberian Peninsular and what is now Switzerland.

But what of the seventeenth-century site that straddles this prehistory? Like the Bronze Age discoveries, there is no evidence of the wreck itself. A number of cannons had been found in the early 1990s, but it was a chance discovery by one diver on a particularly cold, grey spring day that changed everything. Tying a tape measure to one of the cannons, he dislodged his mask. As he refitted it, he noticed something glittering in the gully. He looked closely and spied a gold ingot, and then, with his eyes gradually trained, he began to see gold coins scattered about. By October, the team had recovered more than 400 gold coins and other material.

The coins, it transpired, were Moroccan. They were struck by the Sharifs of the Sa'dian dynasty, who ruled Morocco during the sixteenth and seventeenth centuries. The latest coin found was struck by Sharif al-Walid who reigned between 1631 and 1636. The bulk of them come from the reigns of two rulers, Ahmad al-Mansur (1578–1603) and his son Zaydan (1608–27), with over 100 coins from each reign. Some were pierced with small holes and would at some point have been sewn on a bride's dress as part of a dowry. There was much jewellery too, mostly circular 'earrings' that were worn on a woman's headdress rather than in her ear and amulet cases, brooches and small finger ingots. The fragmentary condition of the gold jewellery and ingots suggests that this may have been a hoard of bullion, exported with the intent of melting it down. During this period, Morocco was awash with gold having gained control of the gold deposits around Timbuktu in 1591. English merchants were particularly interested in obtaining gold and, although the export of gold was banned, the trade was commonplace. In 1585, it was reported that smuggled gold was the main return freight from Morocco. This trade was not straightforward, however, and often merchants were taken hostage and occasionally killed.

Despite tireless searching, there has been no discovery of bulk items of cargo. This probably means the ship was in ballast, carrying no cargo. Experts believe the vessel would either have belonged to Barbary pirates who were raiding the Devon coast at this time, or to an English or Dutch merchant working the busy trade route between Europe and North Africa. The Dutch were also active in the trade with Morocco, which was formalised by a treaty in 1610. Due to their willingness to sell arms to the Sultan, they were the most active trader with Morocco in the early seventeenth century.

At first archaeologists questioned whether the seventeenth-century ship could have been carrying some of the middle Bronze Age material as antiquarian curios. It would have been a tidy explanation, but this was soon discounted. It is a unique site in Britain. The only other known wreck sites are of either Royal Navy ships or East Indiamen. This is rare, tangible evidence, filling out our knowledge of European trade with Britain in a period on which written records are few and far between.

HMS *Crocodile*

Had Charles Vaughan been well enough to 'bear the night air', he might have been able to prevent the tragedy of the wrecking of HMS *Crocodile* in the early hours on 9 May 1784. Instead, because of 'the rheumatism', the lieutenant, an officer highly experienced in navigation, had been in sick bay since Bombay and was, by all accounts, in great pain.

Since leaving India, Vaughan had remained below decks except on the rarest of occasions. To make up the loss, the gunner, Edward Corlett, and the master, Charles Roberts, were ordered to take it in turns on watch on the 24-gun frigate as it made its way past the Scilly isles eastward up the English Channel. The *Crocodile* was returning from India carrying important dispatches for the Admiralty. With a fair wind behind her, she was travelling at great speed despite the fog.

Before retiring for the night, the captain, John Williamson, discussed the route with Roberts, who stated that they needed to veer further eastward. Though the captain objected at first, the master appeared to convince him. However, Williamson took the precaution of ordering the sails to be shortened, including the royals, 'so as to be better able to handle the ship in case of meeting any other ships or vessels'.

Corlett had first watch. He said goodnight to his captain and took up position in the forward part of the ship by the bowsprit. Satisfied that he had just passed the Scilly Isles, the westernmost point of Britain, the gunner relaxed, believing that he would not see land again for some time. But then, at about 2 a.m., there was a sudden jolt, followed by a terrific crashing sound.

'I ran up on deck instantly,' recalled the captain, having been thrown from his hammock, 'and said to the officer of the watch "Good God sir, notwithstanding all the precautions I had taken, you have got foul of some vessel or other?"'

'No, it is worse than that. We are on shore.'

'Where is the land or what is it we are upon?' shouted the captain. But he answered himself. Looking down over the port bow, he learnt the worst. 'The wind was on the shore so we could affect nothing with our sails,' Williamson explained to the court martial board at Portsmouth. In thick fog, the *Crocodile* had hit rocks. All he could see was the white wash battering the rocks, although it was not until much later that they would understand that they had hit Prawle Point, an infamous wrecking point just outside of the Salcombe estuary. The master admitted to the court that he had believed them to be some 24 miles south of Prawle Point, near the Casquets, a few miles north-west of Alderney.

Williamson had to think quickly. He ordered half the men to hoist the ship's boats to take out an anchor to the starboard quarter to try to stop the ship from dragging further on to the rocks. 'I sent the surgeon almost immediately after sinking (as a person who could be best spared) in a boat which came off from the shore with an account of my situation to the Admiralty at Plymouth,' he told the court. The sick lieutenant, who could also be spared, was sent ashore to with the vital role of ensuring that the Admiralty received the important dispatches from India.

The rest of the crew (and they were thirty men short) were ordered to start pumping the water out. With water only sitting at the bottom of the hold, Williamson did not yet fear the worst, and began to think about what he could salvage. He had barely given the order to furl the valuable sails when the ship gave another heavy jolt. Urgently, he ordered the carpenter to cut down the masts to try to lighten the load. The rudder was knocked off and the cabin deck torn up while the carpenter saw to the foremast.

'The water rose so fast,' recalled the captain, 'that we could save nothing. In five minutes or nearly he [the carpenter] told me she just had water in the hold. About two minutes after I looked down myself and saw the water in between decks. Very soon after she came crashing down on her port side.'

The whole process took under an hour and a half. The sea, having swallowed another victim, once again ran eerily smooth.

The battle was not yet over for Williamson though. He planned to salvage as much as he could including the cannons, and commandeered a barn to house his crew. He read them the Articles of War to remind them they were still part of the Navy, listing the naval punishments the Navy regularly administered, ranging from the cat-o'-nine-tails to death, and left them to sleep a few hours.

Unfortunately, young Patrick Crawley, a more adventurous member of the crew, had gone elsewhere for the night, looking for lodgings that could also provide alcohol. But the cider proved too strong for him for he had not drunk alcohol, particularly the notorious Devon drink, for some months. When ordered to leave the establishment, Crawley struck John Burn, a petty officer from the *Crocodile*. The insult could not go unpunished. One month later, on 7 June, Crawley was awarded 100 lashes. The wooden grating, on which he was tied, was hauled from ship to ship in Portsmouth harbour. Williamson's salvage operation was not entirely successful – ten cannon can still be found on the site though little else is left.

While Crawley's final fate is not recorded, both the captain and the master were ordered by the court martial board to 'be more attentive to sounding in the future'.

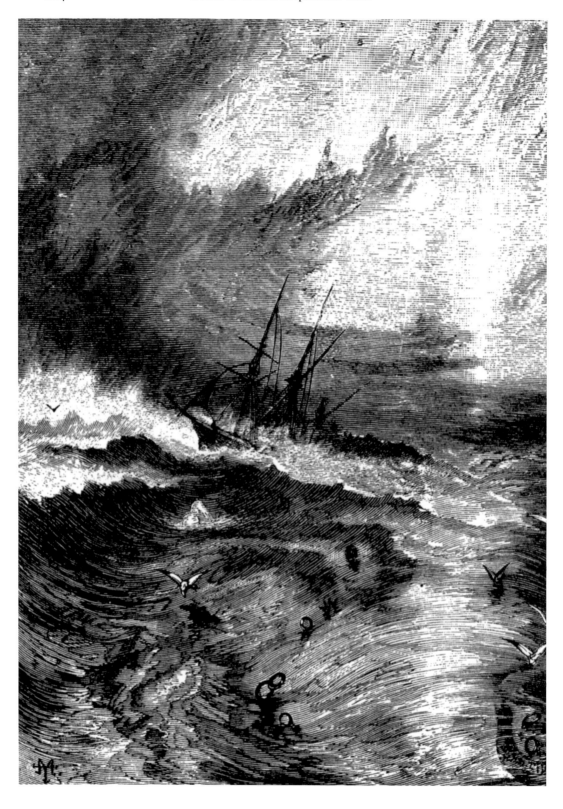

De Boot

Prawle Point in South Devon, just to the east of the mouth of the Salcombe estuary, is one of the most treacherous stretches of sea in England. Stand above on the cliff next to the old coastguard cottages on a day when the wind is blowing hard south-westerly, and the notion of a ship trap becomes clear. This point is the second southernmost stretch in England after the Lizard in Cornwall. Ships coming up the Southern Approaches, having cleared the Lizard, have often made the mistake of believing they are clear of danger and are within a safe distance from the land. Then Prawle Point opens its jaws.

De Boot, a 650-tone ship, was a Dutch East Indiaman returning from China, with, it transpired, a hugely valuable secret cargo, which was not the declared 300,000 pounds of tea. The captain, Jacob van Duijnen, knew the moment the bowsprit pierced the rocks on 8 November 1738 that his ship was finished. The south-westerly gale was blowing ferociously and the white crested waves, like teeth, were now higher than the bows of his ship. A second massive wave and *De Boot* was on the rocks. Quickly, Van Duijnen gave orders for half his men to get ashore to form a human line so that they could transfer the precious cargo.

No shipwreck would be complete without the arrival of scores of locals, allegedly to help the stricken crew. Many turned out to join the human chain. It took much faith on the part of those still aboard to throw their precious boxes into the arms of half submerged men, their arms outstretched to catch. As this process was going on, the captain noticed that Paulus Shultz, the ship's book keeper, was hastily making a note of each box as it left the ship. It was important to keep an eye on the diamonds. Various reports state that there were twelve boxes containing diamonds and rubies. The crew, apparently, was not informed of the boxes' contents.

The news of the wrecking would make Van Duijnen very unpopular in Amsterdam, Hoorn and Enkhuizen, each city housing a Chamber of the Dutch East India Company. Each Chamber was expecting a valuable delivery. This news reached the British press within hours.

Just before jumping off his ship for the last time, the captain, holding one final box of valuable cargo, saw a man he didn't recognise positioned dangerously between the bows of the ship and the rocks, stretching out his arms. With no time to think, Van Duijnen threw the box to him and watched the man, having difficulty under the weight, make the shore. Then he jumped himself.

The captain never forgot this man, or the box. He never saw either again, as he told the *Sherborne Mercury*, giving details of their losses.

Large quantities of tea and other valuable goods (part of the cargo of the Dutch India Man lost off the Praul Head on the 20th of last month [October]) have been taken up along shore from Exmouth to bear her cargo, by report of the captain, was worth near 250,000 sterling!, part of which consisted in diamonds: one of the boxes in which they were contained, being by the captain delivered to a countryman, the fellow had the modesty to march off with the same, and has not been since heard of.

One man was caught, however, for stealing cannons, although it is not recorded how many, and he was evidently persuaded to snitch on his friends: 'A man is committed for stealing iron from the said ship, who has given in a list of a great number concerned in those vile practices.'

Two men died instantly when the *De Boot* crashed against the rocks. A further eight drowned. The ship, built in 1733 in Rotterdam, was armed with forty cannon, one of which is still often spotted by divers. Very little of the cargo was heard of again. The captain later recalled shuddering as he heard the Ming porcelain smashing up beneath his feet in the hold. But there had been nothing either he or his men could have done to save it. The porcelain sank to the bottom and has now become encrusted in the sand and rock. It is an unusual underwater sight.

Awareness of the existence of danger, however, has not prevented a significant number of ships from crashing into these rocks. There are at least eight known wrecks that straddle each other on the seabed.

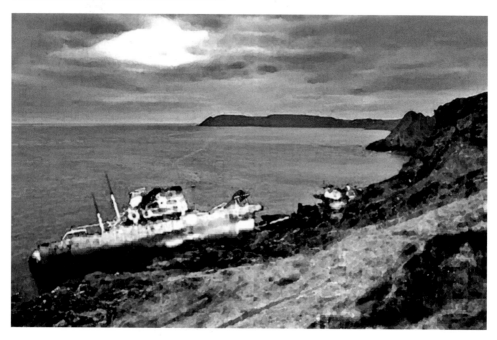

These include the HMS *Crocodile* (elsewhere in this volume). The *Maria*, a Greek steamer, ran on to the rocks in thick fog on 27 June 1892. In 1907, the *Bona*, an 80-ton ketch, was carrying coal from South Wales when she sank, some of which can still be found in the gullies. The *Ida* was also carrying coal when she sank in 1930. Five years later, the *Louis Yvonne*, a French cargo vessel, ran aground and broke up. The *Demetrios*, a cargo ship *en route* to a breakers yard in the Mediterranean, joined this terrible catalogue in a December storm in 1992. Much of her rusting remains lie high on the rock face and serve as a constant reminder to mariners who stray too close. The list is unlikely to stop growing, and land lubbers are unlikely to stop believing that from the cliff top above on a clear, flat calm day they can see shiny, brass like pieces glimmering beneath the water.

HMS *Penylan*

HMS *Penylan*, a Hunt class destroyer, was sunk by enemy action on 3 December 1942, caught up in a vicious stew of E-boats, or Schnellboot, Germany's Second World War attack boats, and one of the fastest types of ship afloat.

She was escorting convoy PW 257, a group of five trawlers and three motor launches, which was proceeding in two columns. The commodore in the Jernland was leading the starboard column and MV *Gatinais* the port column.

It was a calm, clear night with a slight swell from the south-west. The convoy had just passed the mouth of the Dart, heading westwards. Air patrols, on the lookout for E-boats, were flying throughout the night, just seaward of the convoy.

They had made no contact with the enemy. All was proceeding as planned except for one straggler, the SS *Hornsdrug*. Portland shore station radio contacts from her location had been picked up so it was assumed that she was safe. While the *Hornsdrug* was ordered to rejoin the convoy immediately, shore lookout stations were told to disregard her sonar ping or echo, believing they knew her identity. This proved to be a great mistake.

From 3.25 a.m., the shore station began to obtain a number of unidentified plots (denoting unidentified vessels) about 5 miles west of Bolt Head, the direction in which the convoy was headed, moving slowly eastwards and southwards. An hour later, the officers of the watch on the convoy were informed by shore watch at Plymouth of the potential dangers. Yet something went wrong aboard the *Penylan*. The commanding officer never received this early warning.

By about 6 a.m., it had become clear that these plots consisted of two or three groups of E-boats, though it was impossible to tell how many were in each group. The convoy changed course, but by this time it was too late.

Just three hours after the unidentified pings had been obtained, the sky just off Start Point lit up. An S-115 had fired a star shell to search the area. Simultaneously, both Ordinary Seaman McLaughlon, who was on the port for lookout aboard the *Penylan*, and Ordinary Seaman Landen at the bow manning the pom pom guns, sighted a torpedo approaching the port beam. But it was too late to warn the bridge to take evasive action. *Penlyan* was struck amidships and instantly broke in two. Just at that moment, the *Gatinais* that had been leading the port column was struck. She sunk at once, as if she had never been afloat.

HMT *Ensay* and HMT *Pearl* responded with star shells, searching for their invisible enemy. Just in time, *Ensay* spotted a torpedo heading straight for her port bow. She turned hard to starboard and the torpedo just missed. *Ensay* responded with star shells

and shrapnel, but none of her attacks hit home. The enemy disappeared into the night, as silently as she had approached her prey.

Penylan took just fifteen minutes to sink. Her bow rose vertically. The stern section sank first. Within minutes, the sea was littered with life rafts. Thirty-eight died in the attack, many from swallowing engine oil spewing from the wreckage. Five officers and 112 ratings were saved. This was thanks in large part to Surgeon Lt Nigel Seldon Daw from the *Penylan* who was mentioned in despatches. HMT *Pearl* found him struggling under a mass of life jackets and oil 'in a rather bad condition'. Dragged from the sea, he quickly set to work transferring from ship to ship attending to the survivors. Many of the dead are buried in the Bonfire Hill cemetery in Salcombe.

Fighter aircraft were despatched at first light to seek out the retiring enemy. Although they damaged two, the E-boats were able to slip away.

Lt-Com. John Henry Wallace, the commanding officer of *Penylan*, was accused of failure to manage the internal organisation of his ship and failing to spot the E-boats earlier. Failure to make the *Hornsdrug* keep up with the pace of the convoy was also blamed on the *Penylan*. An inquiry ruled that *Penylan* should have sent a motor launch to pick up its straggler; it had become clear in the aftermath that signals believed to have been the *Hornsdrug* were in fact the enemy. The inquiry also criticised the *Penylan* for advancing too slowly in too straight a line, making the convoy a perfect enemy target.

Penylan earns the distinction of being the shortest lived of the Hunt class. Then on her first patrol, she was ordered under the War Emergency Programme in 1940, and was commissioned into service in August 1942. It is little surprise that she broke in two. Hunt class destroyers were quickly and cheaply built, designed as war emergency coastal escorts, too small to operate in deep water. They provided a good weapons platform, though, with four 4-inch guns on the bow and stern, and multiple anti-aircraft guns. But alone they were a poor match against an E-boat, being designed principally as anti-submarine vessels. Despite completion in August, she was not deployed until 1 December after engineers found a number of defects on entering Portsmouth. Today she lies in an east west position off Prawle Point at a depth of around 60 metres, and is a Protected Place under the Ministry of Defence's Protection of Military Remains Act.

HMS *Venerable*, HMS *Cerbere* and T-189

Eight men died and one of the Royal Navy's most well known ships of the line sank in November 1804, all because of one man. The spectacular loss of the third-rate, 74-gun HMS *Venerable* was made all the harder to bear because of her distinguished service.

The Battle of Camperdown in 1797 saw the most significant action between the British and Dutch forces of the French Revolutionary Wars. It was also the *Venerable*'s greatest victory. The French Republican army had overrun the Netherlands and in 1795 the country had become the Batavian Republic, a client state to the French Republic. The French had originally planned for the Dutch fleet, under Admiral Jan Willem De Winter, to defeat Admiral Adam Duncan's North Sea Fleet, then return and transport a Franco-Dutch army to Scotland, and use Glasgow as a base for an invasion of Ireland.

Jack Crawford
From J.S. Copley's Painting.

De Winter's fleet of twenty-six ships put to sea first but Duncan responded quickly, setting sail with sixteen ships, led by his own ship, the *Venerable*. The fighting was intense. While the Dutch side's smaller ships were quickly captured, it was not for some bloody hours that the Dutch were defeated, with the surrender of their flagship, the *Vrijheid,* and ten others and the loss of more than 1,100 men. At one point during the battle, the *Venerable*'s colours (the Admiral's flag), were shot from the mast. Jack Crawford, a sailor, understood too well that its loss was a sign of surrender. Quickly he clambered up the mast to nail back the flag. The expression 'to nail one's colours to the mast' is thought to derive from this moment.

After the battle, Crawford was presented to the King and given a government pension. However, he died a pauper, misspending his windfall, in a cholera epidemic in 1831. Towards the end of the century, his memory was revived by a play by James Roland MacLaren called the 'Jack Crawford, Hero of Camperdown'. A statue of him, which was originally built to about a pub named after him, is now in Sunderland Museum.

Crawford was not aboard the HMS *Venerable* on the disastrous day of 24 November 1804. The ship was at anchor in Torbay with the rest of the Channel Fleet, sheltering from a south westerly gale. But hours later, the wind changed hard to the north-east, driving in from over the headland, seemingly picking up strength at every gust.

Peering through his telescope at the rocks of Berry Head to the south-west, the captain, John Hunter, slightly nervous of his new command (he had not been to sea for three years), worried that if the weather worsened he would barely make them out against the dark grey skies.

At that same moment the Fleet commander, Admiral William Cornwallis, gave the order to weigh anchor. He could not afford to risk eleven ships in such a notorious ship trap as Torbay, fine with the right wind, otherwise deadly. The Navy crews jumped to his command. Each ship prepared to sail. The cables were drawn in, the anchor was lashed to the hulls, and the sails were cast loose and hoisted up. Except that is not quite how it happened aboard the *Venerable*.

In their haste to follow Hunter's orders, one sailor fell from his perch on the anchor and into the darkening sea. The cry of 'man overboard' rang out. The crew quickly launched a boat to rescue the sailor, but in their haste to lower it in, the boat tipped, throwing out Frederick Deas, a midshipman and two seamen. While these three drowned almost instantly, the original sailor was rescued after a second boat was released.

Meanwhile, as the sails were being set and the rescue was underway, the *Venerable* was drifting inexorably towards the bay, which meant that she would have very little room to manoeuver out and around the cliffs of Berry Head. Hunter gave the order to tack to the north-west, but then found himself trying to avoid colliding with the Fleet who were all attempting to escape. By constantly dodging collisions, the *Venerable* was losing ground and being pushed ever closer to the rocks. Then, as suddenly as the wind arrived, it died. At the same time the ship ran aground. As the rain cleared, they could see they were stuck hard under the Paignton Cliffs. Once again the winds howled, this time with renewed ferocity and greater swells.

Hunter ordered the masts to be cut down to try to use them as a bridge to the shore to get his crew off. But with the storm lashing their sides, it was impossible. The sea had reached the level of the lower gun deck now. Desperate to avoid capsizing, Hunter ordered his men to fire distress signals. HMS *Goliath*, HMS *Impetueux* and the cutter *Frisk* came to their aid, but there was nothing that could be done for the ship. Rope ladders were thrown over the stern and the terrified crew, most of who could not swim, were ordered to drop into the rescue boats which were relayed to the shore over the next few hours.

At the time of the court martial in Plymouth on 10 December, the captain was said to have argued that the King would have found the life of a subject preferable to the safety of one of his ships. Hunter lost both his ship and eight men, all because of one man. Yet the court martial acquitted him. Whether it was on these grounds is not recorded. While he then went on to become the Governor of New South Wales, one man, however, who had not displayed the courage of his crew, was given 200 lashes. David Evans, a marine, had to be dragged on deck, too drunk to carry himself. Out of his pockets fell officers' property that he had been stealing from the ward room. His crime was undeniable; he was still clutching a 'tin kettle port of wine'. Whether he survived his beating is not recorded.

The *Venerable* is one of over 100 wrecks from the last 300 years in Torbay, most of which have been discovered by divers over the last 30 years. As a natural east-facing harbour, Torbay is an obvious refuge, until the wind changes direction. One of the earliest recorded wrecks here is the HMS *Savage*, a sloop-of-war that was driven ashore in an easterly gale in February 1762. HMS *Cerbere* was wrecked only nine

months before the *Venerable*. A 10-gun brig, she ended her career here on 19 February 1804.

She was a French prize, captured by HMS *Viper* in Mauritius four years earlier. Like the Channel Fleet nine months later, she was sheltering from westerly winds that were preventing her reaching Plymouth. At about six o'clock, HMS *Terrible*, also seeking shelter, moored close by, too close. The two ships then spent much of the night disentangling their cables from each others. The incident was clearly an omen. Four days later, a freshening north-easterly, the same wind that caught the *Venerable*, began to hit the *Cerbere* hard broadside.

'She was swift on the rocks under Berry Head before my orders for letting go the anchor could be complied with,' the lieutenant, John Patey, commander of the ship, told the court martial a few weeks later. 'In a few minutes she filled with water and sank. I am happy to say no lives were lost.'

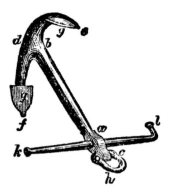

Even if they had succeeded in staying her, Patey told the court martial that the cables were so worn they would have snapped almost immediately. He, like Hunter after him, was acquitted. Torbay already had a reputation as a ship eater.

The most modern wreck in the area, lying almost above the *Venerable*, is that of the German torpedo boat T-189, the only known shipwreck in Devon to have survived the Battle of Jutland of 1916, the largest battleship engagement of the First World War, when famously, the German High Seas Fleet did not realise it was facing the Royal Navy's entire Grand Fleet. Winston Churchill noted of Admiral John Jellicoe that 'he was the only man who could lose the war in an afternoon'.

The star status of the T-189 is little known, due to the German system of renaming boats when newer ones were introduced. During the war, the T-189, then called the V-189, would have played a significant role in allowing the German battleships to escape at the Battle of Jutland. The torpedo boat flotillas were highly trained, fast and light, and acted primarily as scouts as the German navy lacked sufficient light cruisers. Admiral Reinhardt von Scheer, under heavy and relentless bombardment from Jellicoe's ships, affected a 180-degree manoeuvre of his battleships, miraculously without collision, whilst his torpedo boat flotillas, including the V-189, fell into their regular fan formation and emitted a smoke screen so dense that Jellicoe had to cease fire: his enemy had vanished within fifteen minutes.

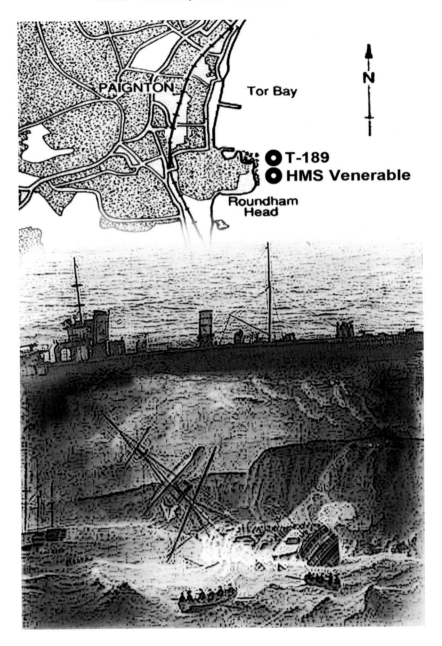

Despite sustaining far greater losses, by the end of the battle the British remained numerically superior in the North Sea: the German High Seas Fleet remained port bound for the rest of the war. However, because the Royal Navy had failed to sufficiently deplete the German enemy, it was forced to maintain a significant presence in the North Sea to contain the High Seas Fleet for the duration of the war.

The T-189 had been under tow from Cherbourg to Teignmouth for scrapping on 12 December 1920, when the line snapped during a strong easterly gale. She sank partly on top of the *Venerable*. There is little left of her now but some mangled steel frames.

Tyger

The establishment of the North American settlements in the second quarter of the seventeenth century, including St John's at Newfoundland in Canada, brought the need for trade in woollen goods and household stores. Devon gentry, many of whom had themselves founded the Canadian and North American plantations, turned to their compatriots back home for the trade. The ports of South Devon, among them, Exeter, Dartmouth and Bideford, were transformed by this lucrative arrangement. Plymouth profited too, both by the trade and the almost incessant wars between 1689 and 1815 and the end of the Napoleonic era. A great dockyard grew up from the original marshland. By the early eighteenth century, Devon's ports had become the largest tobacco ports in England. People came to settle here in large numbers.

The North American settlements, however, needed constant defending, principally from the French. So whilst the new arrivals were anxious to expand, they found their ambitions stymied by the Royal Navy, which often delayed the granting of land, preferring to reserve the hundreds of thousands of acres of timber for colonial defence and shipbuilding needs. For this service, reinforcements were regularly required.

The transport ship *Tyger* was on one such mission, sent to Newfoundland to bolster Lieutenant General Phillip's regiment: there were 250 men aboard. The ship, however, never made it out of the English Channel. Instead only eighty men survived the ferocious storm that battered the ship against Berry Head, at the mouth of Torbay.

Patrick Whyte, the master of the *Tyger*, gave evidence at an enquiry into the loss of the ship, though this had to be delayed as Whyte had broken his leg when he was thrown against the rocks.

Provisions for the troops, to last one year, were loaded on at Deptford. The stores included arms and ammunition, bedding and food, for which the Admiralty was to pay the owner of the ship Chauncey Townsend 12 shillings per ton (about one cubic metre) a month 'for so many tuns as the ship could measure'. Once the 242 land forces had embarked, the *Tyger* was instructed to meet John Brett, captain of the Sunderland, at Portsmouth, as he was appointed to convoy the troopship on to Plymouth.

Expecting to set sail for Canada soon after, the master was surprised and peeved to receive new instructions that he was to make for Annapolis Royal rather than St John's. No sooner, however, had this order been given than he was instructed to join a convoy to Spithead. A few days later, the orders changed again. The *Tyger* joined Admiral Henry Medley off the Isle of Wight 'with a large fleet of ships bound westward'.

At eight o'clock the following morning, Whyte told the enquiry, they were ordered to anchor in Torbay. The next day, the Admiral made the signal to weigh anchor, but a north-easterly wind, which moments ago had been blowing from the opposite direction, multiplied in strength into a hurricane. There was instant confusion as the ships, trying to avoid the infamous cliffs of Berry Head, were forced to cut their cables to flee. Whyte was reluctant at first to cut, fearing that he would only come up against the rocks or the other ships. He gave orders to turn the ship about, but found that the *Tyger* could simply not weather Berry Head. 'The wind sailing the ship', he told the inquiry, 'was by the violence of the sea hove against Berry Head'. Whyte, not given to exaggeration, declared he was, aside from a broken leg 'otherwise much bruised and in 10 minutes the ship sunk'. Records state that in all 170 soldiers, 6 sailors and 6 women drowned.

The exhausted survivors did their best to rescue the ship's stores, but with little success. Her papers were also lost, but Townsend was determined to at least recoup his financial losses, if not his honour. The loss of the ship, he told the Admiralty lords, was 'owing to her badness', else she would have stood a greater chance in the storm. Furthermore, he argued, the ship's orders had been confused and wrong. Thomas Corbett, acting for Townsend before the hearing, lodged two protests: 'The first on the ship being ordered to proceed to Annapolis Royal instead of St John's, for a deviation from the Charter Party, and the latter after the ship was lost, for being ordered to return to Portsmouth, when he was got so far in his voyage as Plymouth.'

But their lordships were not to be moved. According to the hire agreement, they stated:

> In the case of the ships being taken, sunk, burnt or otherwise destroyed by the enemy, the value of her (according to an appraisement made by the officers of Deptford Yard) was to be paid by his Majesty, reasonable wear and tear being deducted, but no stipulation to pay for her in case of being lost in any other manner than before described.

Nor were the lords going to accept that the ship was in poor condition. 'We have no reason to think,' they said in phrases reminiscent of modern day arguments with intransigent insurance companies, 'that the loss of her proceeded from that, because the officers of Deptford Yard reported her to be a fit ship to perform the service, and Mr Brixton the builder who fitted her, has acquainted us that she was but three years old, a well-built ship, and strongly bolted, and that she was caulked all over before she went out of his dock on this service.' It is not recorded how Townsend recouped his losses, but it was not through the Admiralty.

Glossary

Astern – towards the rear.

Bow – the front of the vessel.

Conning Tower – raised superstructure, usually armoured platform, on submarines, battleships and armoured cruisers. Acts as an observation post for navigation. Also main entrance to submarine.

Dendrochronology – the scientific method of dating timber based on the study of of tree-ring patterns. The date given is the date the tree was felled.

First-rate, second-rate, third-rate ships of the line – The first classification system began in 1626 and was based on the number of men. Samuel Pepys, Secretary to the Admiralty, revised the system and in 1677, the rating was determined by the number of guns which would then dictate the number of crew required. The system indicated whether a ship could stand in the 'line of battle'. First rates usually carried about 100 guns, although in later years the numbers varied up to 120. These ships had three decks and could carry over 850 crew. Although they were the most powerful, they were very heavy and hence slow. Second rates would have carried between 80 and 90 guns, and a third-rate typically between 64 and 80. Sixth rates were the smallest rated Royal Naval ships carrying between 18 and 28 guns on a single deck. Rated ships always had a captain's command, whereas unrated ships could be commanded by more junior post captains.

Fore and aft – bow to stern.

Lee shore – A shore that lies on the lee or protected side of the ship. The ship may therefore be in danger of being blown on to it.

Mizzen mast – The mast just aft of the main mast. On a three-masted vessel there is a fore-mast, main-mast and mizzen-mast.

Port – to the left.

Starboard – to the right.

Stern – to the rear, aft.

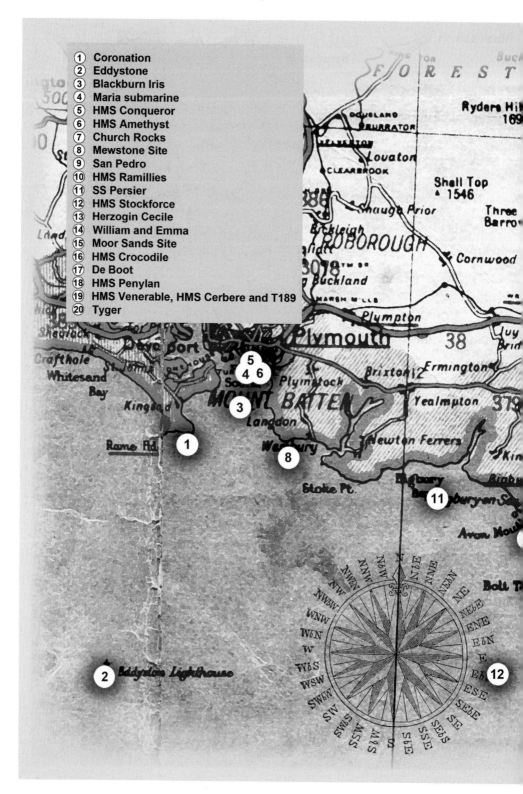

1. Coronation
2. Eddystone
3. Blackburn Iris
4. Maria submarine
5. HMS Conqueror
6. HMS Amethyst
7. Church Rocks
8. Mewstone Site
9. San Pedro
10. HMS Ramillies
11. SS Persier
12. HMS Stockforce
13. Herzogin Cecile
14. William and Emma
15. Moor Sands Site
16. HMS Crocodile
17. De Boot
18. HMS Penylan
19. HMS Venerable, HMS Cerbere and T189
20. Tyger

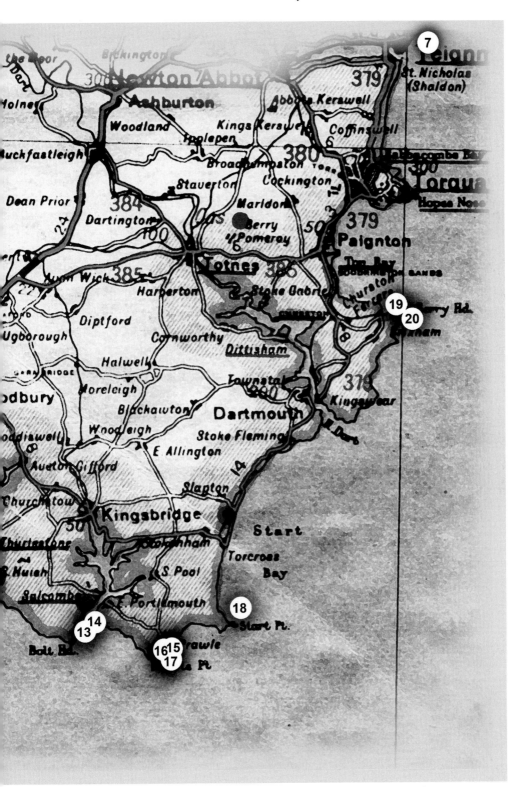

Bibliography

Ashdown, J. B., 'Oil jars', *International Journal of Nautical Archaeology*, 1, 147–153(1972)

Clarke, N., n.d. *Shipwreck Guide to Dorset and South Devon* (UK: Nigel Clarke Publications)

Chatterton Keble, E., *Q-Ships and their Story* (UK: Sidgwick and Jackson Ltd, 1922)

Defoe, D., *From London to Land's End* (UK: Biblio Bazaar, 2012 [1724])

Dunn, M., *The Looe Island Story* (UK: Polperro Heritage Press, 2005)

Farr, G., *Wreck and Rescue on the Coast of Devon* (UK: D. Bradford Barton Ltd, 1968)

Fenwick, V., and Gale, A., *Historic Shipwrecks, Discovered, Protected and Investigated* (UK: Tempus, 1998)

Greenhill, B., and Hackman, J., *Herzogin Cecilie: The Life and Times of a Four-Masted Barque* (UK: Conway Maritime Press, 1991)

Hesketh, R., *Devon Smugglers* (Launceston, UK: Bossiney Books, 2007)

Holland Rose, J., Newton, A. P. and Benians, E. A., (eds.) *The Cambridge History of the British Empire* (UK: Cambridge University Press, 1929)

Hoskins, W. G., *Devon* (UK: Phillimore, 2011)

Jefferis, R., and McDonald, K., *The Wreck Hunters* (UK: George G. Harrap and Co., 1966)

Lake, D., *Smoke and Mirrors, Q-Ships against the U-Boats in the First World War* (UK: The History Press, 2009)

Lecky, H. S., *The King's Ships*, Vol. 1, 2 and 3 (London: Horace Muirhead, 1913)

Lloyd, C., *The Nation and the Navy* (London, UK: The Cresset Press, 1954)

McDonald, K., *Great British Wrecks*, Vol. 3 (UK: Underwater World Publications, 1986)

McDonald, K., *Dive South Devon* (UK: Underwater World Publications, 1985)

McDonald, K., *The Wreck Walker's Guide* (Sevenoaks, UK: Ashgrove Press, 1982)

McDonald, K., *Shipwrecks of the South Hams* (UK: Wreckwalker Books, 2002)

McKenna, R., *The Dictionary of Nautical Literacy* (US: International Marine, McGraw Hill, 2001)

Middlewood, R., 'Mewstone Ledge site', *International Journal of Nautical Archaeology*, 1 1972, 142–147

Mitchell, P., *The Wrecker's Guide to South West Devon* (UK: Sound Diving Publications, 1992)

O'Brian, P. (consultant editor Richard O'Neill), Patrick O'Brian's Navy, *The Illustrated Companion to Jack Aubrey's World* (UK: Salamader Books, 2003)

Oppenheim, M. M., *The Maritime History of South Devon* (UK: University of Exeter, 1968)

Steffy, J. R., *Wooden Ship Building and the Interpretation of Shipwrecks* (US: Texas A&M Univesrity Press, 2006)

Trelawny, J., *The Islanders* (UK: Beavers' Press, 2007)

Walsh, M., *Stories, Lyrics and Legends of the West Country* (UK: Simpkin, Marshall, Hamilton, Kent & Co, Ltd., 1908)

Zweig, S., *Magellan* (UK: Pushkin Press, 2011)